LEGENDARY LC

OF

NEW HAVEN

CONNECTICUT

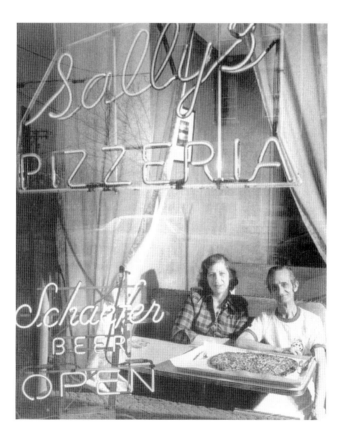

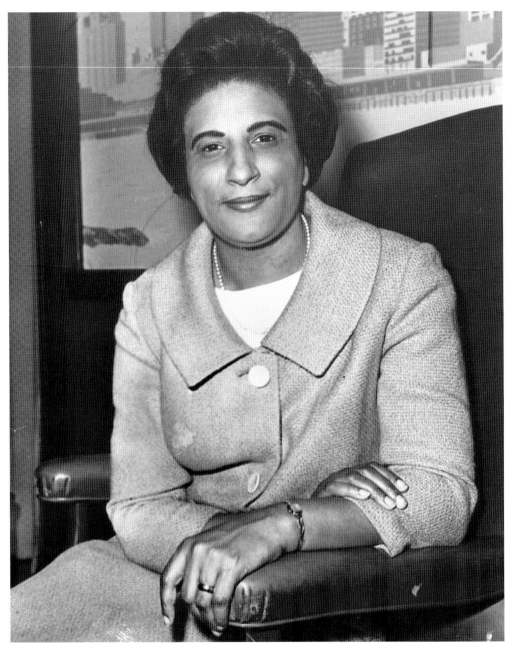

Constance Baker Motley
After an amazing career in civil rights, this New Haven native became the first African American to serve as a federal judge in 1965. See page 29 for more information. (Courtesy of Library of Congress.)

Page 1: The Consiglios
In 1938, Sally and Flo Consiglio opened Sally's Apizza, located down the block from Frank Pepe's Wooster Street. The storied Sally's Apizza place is still run by the Consiglio family. This photograph is from around 1975. See page 113 for more information. (Courtesy of Sally's Apizza.)

LEGENDARY LOCALS

OF

NEW HAVEN

CONNECTICUT

COLIN M. CAPLAN

LEGENDARY
LOCALS

2/1/2020

Legendary Locals is an imprint of Arcadia Publishing
Charleston, South Carolina

Printed in the United States of America

Library of Congress Control Number: 2013933331

For all general information, please contact Arcadia Publishing:
Telephone 843-853-2070
Fax 843-853-0044
E-mail sales@arcadiapublishing.com
For customer service and orders:
Toll-Free 1-888-313-2665

Visit us on the Internet at www.arcadiapublishing.com

Dedication
This book is dedicated to legends in my life, Arthur, Irving, Eddie, and Muriel, who blessed our world with their presence.

On the Front Cover: Clockwise from top left:
Richard C. Lee, mayor (Courtesy of NHM; see page 30); Walter Chauncy Camp, "the father of American football"; (Courtesy of YMA; see page 92); The Five Satins, doo-wop band (Courtesy of the author; see pages, 100, 101); Joseph Cinque, freedom fighter (Courtesy of LOC; see page 27); Jennie Cramer, murder mystery (Courtesy of NHM; see page 122, 123); Donald Grant Mitchell, distinguished author (Courtesy of the author, see pages 90, 91); Frank Pepe, pizza legend (Courtesy of *Yale Daily News*; see page 110, 111); William Baldwin Beamish, woman disguised as a man (Courtesy of the author; see page 120, 121); Bun Lai, sushi innovator (Courtesy of Bun Lai; see page 116).

On the Back Cover: From left to right:
Oliver F. Winchester, gun manufacturer (Courtesy of the author; see pages 72, 73), William Howard Taft, US president (Courtesy of JT; see pages 20, 21).

CONTENTS

ACKNOWLEDGMENTS

To my family, friends, colleagues, and community, I owe a lot of gratitude for being alive and being able to do what I love and share this with you all. To going with the flow, which has pulled me in my intended direction, and for any resulting bruise, I gladly accept. To all of the contributors who helped me complete this book, knowingly or not, you are being acknowledged. If you have read this far, I would advise to keep reading!

Index to source abbreviations:

LOC	Library of Congress
NHM	New Haven Museum
JT	Joseph Taylor
YMA	Yale Manuscripts and Archives
JHS	Jewish Historical Society
NHFPL	New Haven Free Public Library
USPTO	United States Patent and Trademark Office

If unattributed, the image is courtesy of the author.

INTRODUCTION

This is a book about legendary people from my hometown. I have gathered a group of characters together for the readers' enjoyment. Some of these people show up in general history books, but others are the unsung heroes—the people who live next door. There are characters who are going to make hearts swell, and there are some unsavory ones too. In all, this book provides a fun way to explore the people and culture of this vibrant community, past and present.

To state a fact, this is a land of ever-changing habits, and when the locals find something good, they want to keep it for themselves. The Quinnipiac tribe, New Haven's original inhabitants, had plenty of clams, oysters, deer, trees, and land to go around, so when the English Puritans made contact with them, sharing these delights with the newcomers was the going rate. But for the English, sharing land with people who they considered "heathen" was not in the books. Beginning in 1638, when New Haven was founded, the habits of the Quinnipiac were completely upturned, and what was once their shared land, now had busy colonists building fences and clearing the forest. This set the stage for the next 100 years.

With the plantation and port in full swing, the settlers formed New Haven Colony, creating the hierarchical system that the Puritans had desired to be their own. Industry rose slowly, and religion and theology became the focus. It was only after all of the initial clearing, road building, and house constructing that people could take time to look at their surroundings and appreciate them. Beer was first brewed in 1646, and soon after, trade with Barbados brought molasses and rum. The forests were turning to fields, and the port began to look like a bustling village.

When New Haven became the seat of Yale College, it attracted a new breed of thinkers and doers. Townsmen became students, and students became professors and statesmen. The city began to show its weight in the 1700s. It was valuable enough that, during the Revolutionary War, the British were compelled to attack the city in 1779. Their goal may have been to plunder the town, but it did not take long before 2,000 British troops gulped down every last barrel of rum and consumed enough of it to be considered useless. After two days of depleting supplies, they abandoned the city.

The city incorporated in 1784, and industry began to dig into the pristine landscape. The scars of manufacturing that began at this time started a new habit of maximizing resources. Water, wood, and coal made the gears move. People did not want to wait six months to have a watch, a carriage, a gun, a boot, or a corset. They wanted to make a bunch of them as fast as they could and so began our industrial revolution. As evidenced by the hundreds of inventions that were made here, people were eager to develop methods.

New Haven was at the front of industry, transportation, housing, schools, and social life. The immigrants heading to America from Europe were eager to take part in these activities. They did so; however, each group had to prove itself to the last, with the Yankees being at the top of the totem pole. Slavery was getting less and less prevalent in the city too, and blacks found life here tolerable. But they were still at the bottom of the totem pole, just above the Native Americans. Women, too, were universally under the rule of a male-dominated society.

In the age of the automobile, the radio, and processed food, New Haven was jam packed with people from around the world, sharing space and food and laughter and punches. Movie houses, department stores, saloons, salons, restaurants, and hardware stores filled every street downtown and on the main avenues. This mingling allowed people of different backgrounds share their cultural space, with English being the common language.

Into the 20th century, the landscape was changing; farms were giving way to suburban development, at first for only the most privileged people of select descent. The access to wider spaces with less people, noise, and pollution began the process of the city's decline. The last straw to send people and jobs to the suburbs was the slum clearance, as well as highway construction, in the 1950s. This radical change in landscape and the forced resettlement of those in the way meant racial tensions mounting in the 1960s and 1970s; part of the city was shut down during the 1967 riots. This was also a time when rules of equality were being established for all. Yale University began accepting women in 1969, and there was a social backlash against the older generation and the Vietnam War.

I was brought up here just after all of the turbulence from the 1960s and 1970s. I experienced a city and community trying to pick up the pieces. There was also this overwhelming feeling among my peers that this place held no future for an inspiring mind, and most of my friends from school days left town. I defied that mentality, finding an interest and beauty in corners of the city that others had abandoned. I did leave for college, but I had suspected that I would return. My appreciation for this city has been built on bones of the past, but it thrives on the endless wonders, the overwhelming natural beauty, and the idea that every person, building, site, stone, and shell has a story to tell. My passion has become my job, and my work has only just begun. This book gives some insight to the stories that inspire me.

CHAPTER ONE

Lead the Way

As might be expected, the stories in this chapter are about the leaders. Some of them led by persuasion or action, while others led by force. Looking back to recorded history, every population had a leader or chief. The earliest known chief here was Momauguin, sachem of the Quinnipiac. He accepted the terms of the incoming leader from England, John Davenport, with his band of Puritans. City leaders include New Haven's first elected mayor, Roger Sherman, who was also a key player in the formation of the country; and Hobart B. Bigelow, an industrialist who wielded his power to become mayor.

Many leaders first gain the trust and faith of their community and then easily transition to decision-makers for the community. Religion led many people to accept the words of their pastors, and Leonard Bacon was one such minister. Leaders would also set examples, like brothers Simeon and Nathaniel Jocelyn; they were artists and social reformers who used their talents to try to change society. Ezra Stiles was president of Yale College and was influential beyond the walls of academia. He liked to mingle with other cultures, absorb their teachings, and then return those lessons to his pupils. Augustus Russell Street was endowed with money and knowledge, which he wielded to benefit all, creating an early school of fine arts. Fr. Michael J. McGivney became a leader through his suffering, and he filled a gap for people feeling despair by creating the Knights of Columbus. Doris B. Townshend has preserved the area's history, and she has educated people through her writing, showing that leadership can be held at the tip of a pen. Without all of these amazing people, New Haven would likely not have gained its legacy as a place of higher education, understanding, and will.

Momauguin

The Quinnipiac tribe called the land home on which most of New Haven sits, and Momauguin was the tribe's chief. These Native Americans wintered near Sleeping Giant and summered at the shore of the Quinnipiac River. Upon contact with the English colonists in 1637, the Quinnipiacs helped teach the newcomers how to fish and survive the cold winters. After selling their land to the Puritans, their remaining land on the East Shore was the first Native American reservation in the country. After years of uprooting, disease, and war, the Quinnipiac people moved on, and only a handful in this area can trace their roots to the ancient people. (Drawing by Irving E. Hurlburt.)

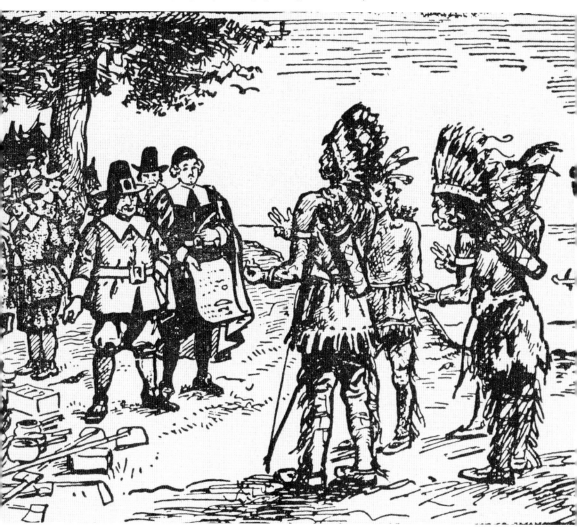

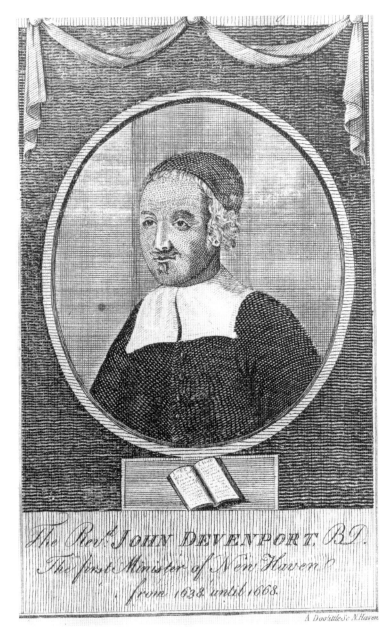

The Revd JOHN DEVENPORT, B.D.
The first Minister of New Haven
from 1638 until 1668.

A Doolittle Sc. N.Haven

John Davenport

John Davenport was the vicar of St. Stephen's in London, England, but he decided to venture to the New World to escape conflicts over his Protestant views. He joined Theophilos Eaton and a party of merchants and traders to Boston in 1637. Not finding Massachusetts satisfactory, Davenport joined his band of Puritan settlers and headed to Quinnipiac in 1638 to establish a new theocratic city. On April 24, 1638, Davenport led a sermon for the settlers under a large oak tree near the present corner of College and George Streets. Davenport was the spiritual leader for New Haven Colony until 1665, when Connecticut Colony absorbed it, and he left for Boston. Davenport Avenue, an old road leading to Milford through the Hill neighborhood, carries his namesake. (Engraving by Amos Doolittle, courtesy of NHM.)

Ezra Stiles (BELOW AND OPPOSITE PAGE)

Rev. Ezra Stiles, depicted below, was born in North Haven, graduated from Yale College, and became a highly respected educator, theologian minister, historian, and author. He moved to Newport, Rhode Island, in 1755 and, while there, helped found Brown University. Although Reverend Stiles was given an African slave, he abhorred slavery and freed the young man, whom he named Newport. In 1778, Reverend Stiles returned to New Haven to become the president of Yale College. When the British attacked the city during the Revolutionary War on July 5, 1779, Reverend Stiles led a Yale militia down Davenport Avenue to destroy the West River Bridge and halt the enemy's progress; a map of his planned attack is pictured at right. He was a Hebrew scholar, and with insights from Benjamin Franklin, Reverend Stiles began experimenting with electricity. In 1968, Yale University built a new college building, naming it Stiles College. (Below, engraving by R. Mouthrop & D.C. Hinman; opposite, drawing by Ezra Stiles.)

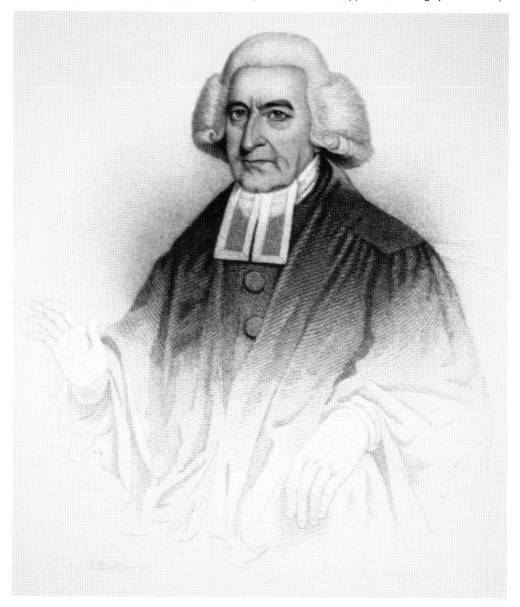

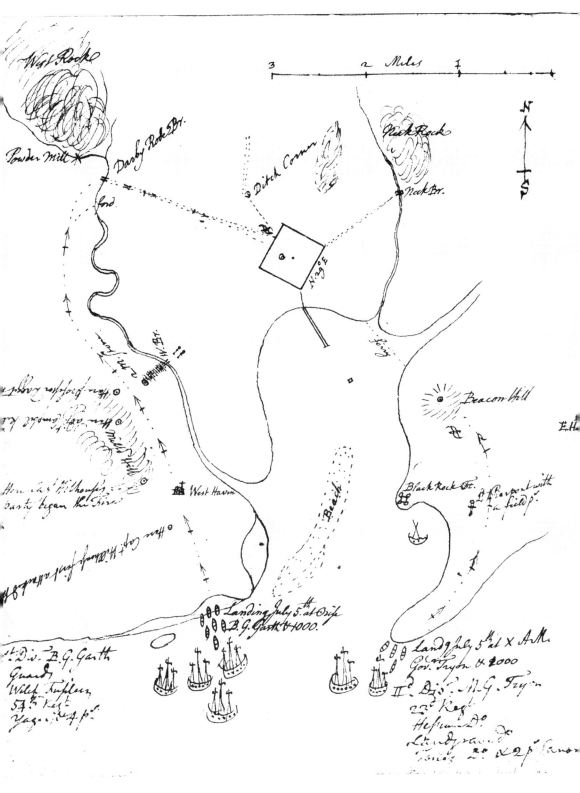

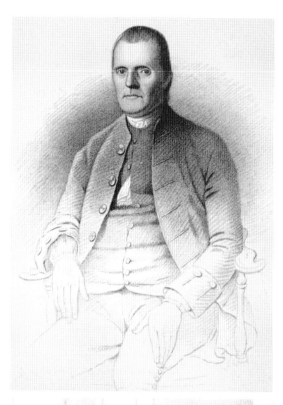

Roger Sherman

Dubbed "the Signer," Roger Sherman was one of the founding fathers of this country, and his influence helped create the rules of the land. He passed the bar becoming a lawyer, then a US congressman, then the first mayor of New Haven in 1784. Sherman served on the Committee of Five, depicted below in an 1876 engraving, and was the only man to sign all four great US state papers: the Continental Association, Declaration of Independence, Articles of Confederation, and Constitution. His homesite in New Haven on Chapel Street bears the name Sherman's Alley, and other places—Sherman Avenue and the town of Sherman, Connecticut—also recognize this man's legacy. (Left, engraving by Earle & D.C. Hinman; below, engraving by Currier and Ives, courtesy of LOC.)

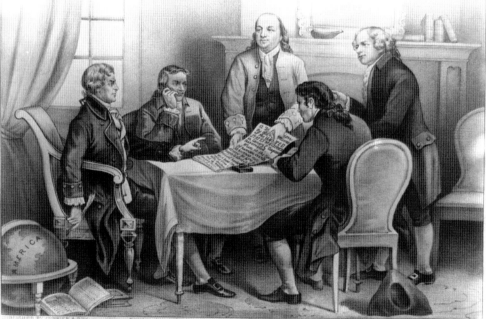

THE DECLARATION COMMITTEE.

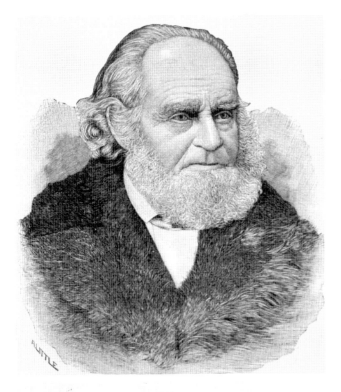

Leonard Bacon
While living in Detroit, Michigan, Leonard Bacon began his religious practice as a missionary to Native Americans. Later, he moved to New Haven to attend Yale College, graduating in 1820. From 1825, Bacon was the pastor of the First Congregational Church on the Green. He edited and founded Christian theological papers and became an instructor at Yale. Bacon was known for his views of liberal orthodoxy and was a staunch abolitionist. His writings influenced Pres. Abraham Lincoln in the cause against upholding slavery in the South. Pictured below around 1920, the First Congregational Church is on the left. (Left, engraving by A. Little.)

Simeon and Nathaniel Jocelyn

These two brothers were early antislavery advocates and faced adversity from their white-dominated community. Simeon Jocelyn was Yale educated and became the pastor to the Temple Street Church, pictured at right around 1905. It was a black congregational church that later moved and became the Dixwell Avenue Congregational Church. Simeon Jocelyn attempted to form a "negro college" in New Haven, but this plan came to a halt by city and Yale leaders. Nathaniel Jocelyn was a remarkable painter, noted for his accuracy and composition. Both brothers were involved in assisting those traveling to freedom via the Underground Railroad. As real estate investors, the brothers designed Spireworth Square (now named Trowbridge Square) and Franklin Square (now named Jocelyn Square), pictured in the 1888 map below. They were their attempts at making working-class, mixed-ethnic neighborhoods. (Right, courtesy of JHS; below, map by G.M. Hopkins.)

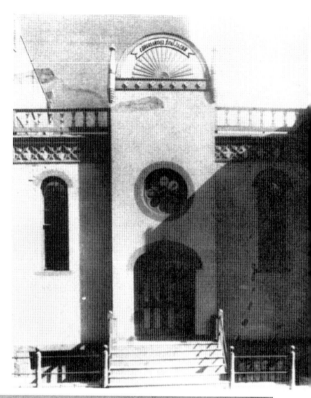

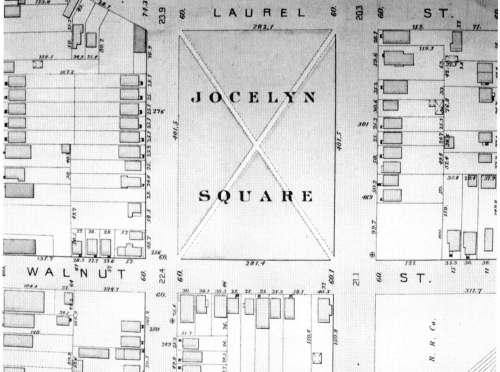

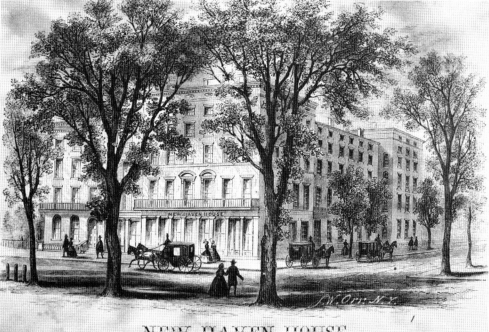

NEW HAVEN HOUSE.

Facing the New Haven Green. Corner of Chapel and College Streets.

S. W. ALLIS, PROPRIETOR.

Augustus Russell Street

Son of hardware store owner Titus Street (see page 79), Augustus Russell Street attended Yale, graduating with a degree in law in 1841. Augustus Russell Street traveled to Europe to study language, and upon his return to New Haven in 1848, he commenced the construction of the largest and grandest hotel between New York and Boston. Designed by Gervase Wheeler and Henry Austin (see page 64), it was called the New Haven House, pictured above in an 1864 drawing. In 1863, Street donated the hotel to Yale to fund Yale's first art school, the first of its kind in the country, built in 1866 and designed in the High Victorian Gothic style by Peter Bonnet Wright. Street's donation intended that Yale keep an entrance of the new building facing the street to allow the institution to benefit New Haveners. The art school's building was named Street Hall (pictured at the left in 1881). Street passed away the same year it opened, in 1866. (Above, drawing by J.W. Orr, courtesy of NHM.)

17

Hobart B. Bigelow

Raised in North Haven, Hobart B. Bigelow eventually made his way to New Haven. His focus was making boilers, which he began on his own in 1861, heading the Bigelow Company, depicted below in 1895. The company's manufacturing plant was on River Street in Fair Haven. He was mayor of New Haven for one term, then governor of Connecticut for one term, as well. Bigelow continued to head his boiler company and also founded the National Pipe Bending Company across the street. He died on October 12, 1891, at the New Haven House. (Left, engraving by W.T. Basher; below, engraving by Kyes & Woodbury.)

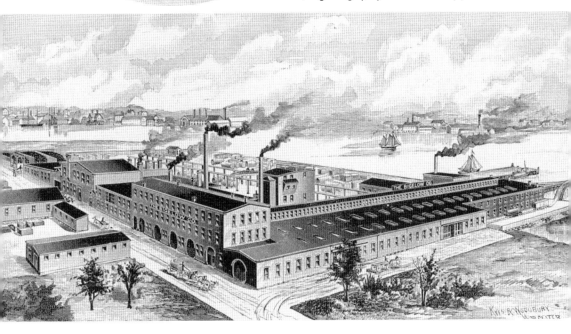

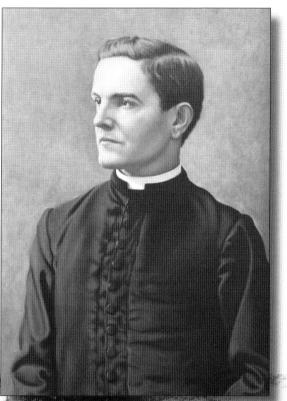

Fr Michael J. McGivney

By the time he was 20 years old, Michael J. McGivney had seen his share of hardship growing up in a household of 13 kids in an immigrant community. After many of his siblings and father died, he came to New Haven and became the assistant pastor of St. Mary's Roman Catholic Church on Hillhouse Avenue, seen below around 1895. He founded the Knights of Columbus, or KofC, with a group of parishioners to help individuals cope with life's losses. The KofC is one of the largest fraternal organizations and insurance companies in the world. The group is headquartered in a large office tower on Church Street. (Left, courtesy of Richard Whitney.)

19

William Howard Taft

Dubbed "Big Lub" because of his size, William Howard Taft came to New Haven first to attend Yale. His father also attended Yale and was one of the founders of Skull and Bones, a Yale secret society. He rose in the political world from governor general of the Philippines to secretary of war and then was voted president of the United States in 1908. Taft served one term and is noted for helping to ratify the Sixteenth Amendment, regarding income taxes, in 1913. Seen at right, Taft was at a 1914 tree planting on the Green. In New Haven, his brother and other investors built a new hotel to rival any in New England, naming it the Hotel Taft, located on the corner of Chapel and College Streets. After his presidency, Taft taught law at Yale until he was appointed chief justice in 1921. Below is a c. 1930 postcard. (Right, courtesy of JT; below, printed by the Harold Hahn Co.)

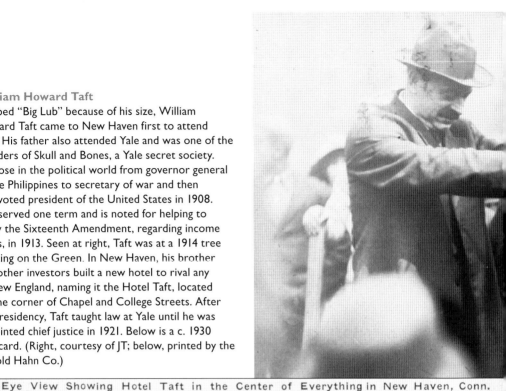

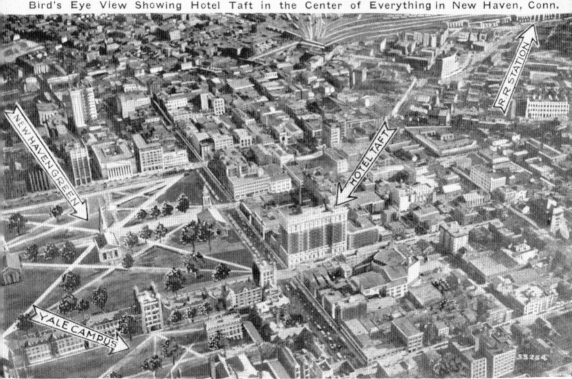

Bird's Eye View Showing Hotel Taft in the Center of Everything in New Haven, Conn.

NEW HAVEN GREEN

R.R STATION

HOTEL TAFT

YALE CAMPUS

J. C. La Vin President.

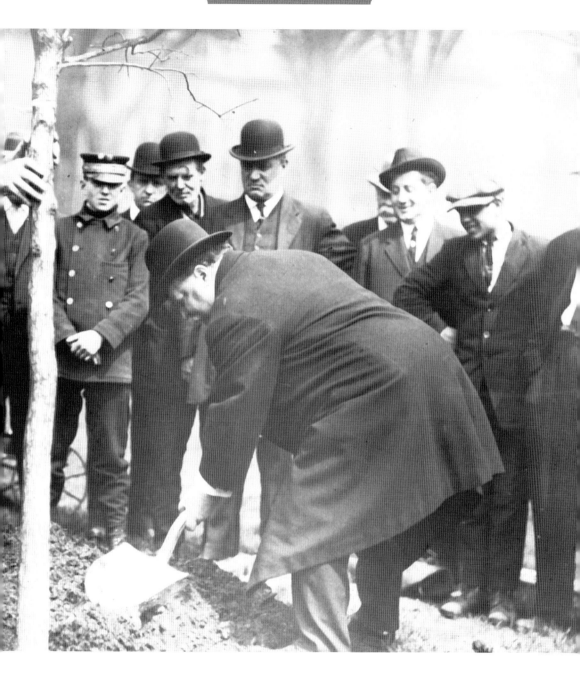

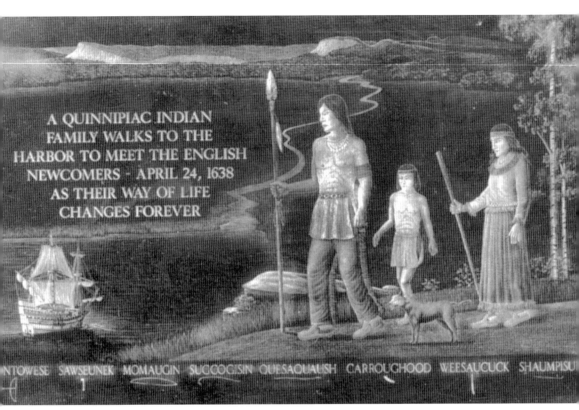

A QUINNIPIAC INDIAN
FAMILY WALKS TO THE
HARBOR TO MEET THE ENGLISH
NEWCOMERS - APRIL 24, 1638
AS THEIR WAY OF LIFE
CHANGES FOREVER

NTOWESE SAWSEUNEK MOMAUGIN SUCCOGISIN QUESAQUAUSH CARROUGHOOD WEESAUCUCK SHAUMPISU

Doris B. Townshend
Doris B. "Deb" Townshend, a prolific local author and historian, married into one of the oldest families in New Haven, whose mansion and estate sit in the East Shore neighborhood on Townsend Avenue, which is aptly named for the family (see page 75 for another family member). In 1804, the Townshends built their house, named Raynham after their ancestral home, Raynham Hall, in Norfolk, England. Deb Townshend has authored a number of important local histories; led the restoration of the local Quinnipiac tribe's ceremonial rock, which was a large boulder hidden under weeds in a neighbor's backyard; and helped erect a monument to commemorate the Quinnipiacs at Fort Wooster Park. Pictured is the Quinnpiac Monument.

CHAPTER TWO

Hard Decisions

This chapter is about people who have been faced with hard decisions have eventually defined them. New Haven's growth depended on people making decisions that, in retrospect, they may have regretted or they might have done again. The Regicide Judges, who condemned King Charles I to death, believed that their decision was just and worthy at the time. The aftermath of their decision forced them to flee and hide. Their desire to live allowed them to prevail. Benedict Arnold was also charged with making decisions that would put him in danger. This was clearly the case when he switched loyalty during the Revolutionary War.

Joseph Cinque was an African slave who, at first opportunity, attacked his captors and seized their slave ship. He would rather have died than remain a slave. Augusta Lewis Troup felt the immense inequality of being a woman, and she made it her life's quest to press the issue of equal rights for women. Constance Baker Motley faced adversity being a black woman, but that did not stop her from persevering. She never stopped believing that she had no limits to her success and influence.

Politicians often face hard decisions. Successful politicians walk the fine line between upsetting one group while benefitting another. Richard C. Lee became mayor of New Haven with an agenda to modernize the city. Despite his belief that he was creating a model city, what he ended up doing was ripping people from their homes and businesses. These are some of the people who have had to make difficult decisions when no one else would step in.

The Regicide Judges

Edward Whalley, his son-in-law William Goffe, and John Dixwell were English judges who condemned King Charles I to death. After the king's son Charles II regained power, they fled to North America. Dixwell arrived in New Haven and took on the alias James Davids; the British had already assumed he was dead. Whalley and Goffe came to New Haven in 1661, where many in the local community supported the judges' cause. At first, Whalley and Goffe hid in John Davenport's (see page 11) cellar, but when word came that British soldiers were on their way to catch them, a new hiding spot was found. For three weeks, Whalley and Goffe hid in a cave, since called Judge's Cave, in the cracked spaces under a large bolder on top of West Rock, pictured here around 1868 (see page 88). This was in the middle of the wilderness, and only one resident, Richard Sperry, lived within walking distance. Sperry and his wife brought food to the judges, who were growing cold, hungry, and scared. There were bears, wolves, and mountain lions on the prowl, not to mention the British troops. Other hiding spots were found for the judges including under a bridge, in a mill, and then back at the cave. All three judges escaped capture. Whalley and Goffe were believed to have settled in Hadley, Massachusetts, and Dixwell died in New Haven. Three major roads leading out of town—Whalley Avenue, Goffe Street, and Dixwell Avenue—commemorate all three. (Photograph by Henry S. Peck.)

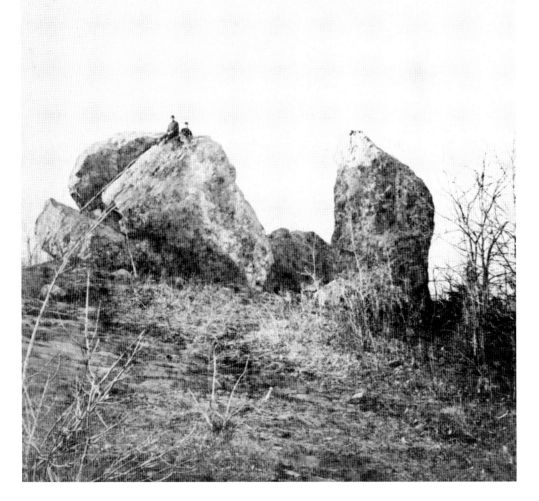

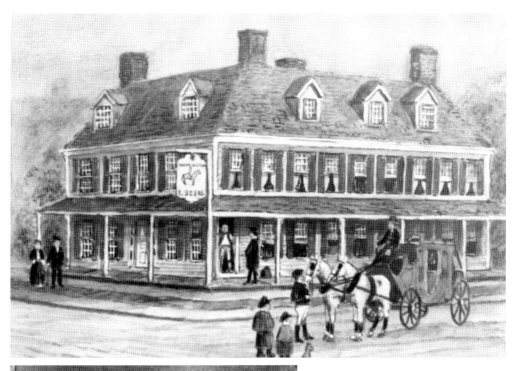

THE PATRIOTIC CITIZENS OF NEW HAVEN
WITH SUPREME FAITH IN GOD
AND IN THE RIGHTEOUSNESS OF THE CAUSE
OF THEIR COUNTRY RALLIED HERE
WEDNESDAY JUNE 28. 1775
TO WELCOME AND BID GOD SPEED TO
GEORGE WASHINGTON
WHO WAS ON HIS WAY FROM PHILADELPHIA
TO CAMBRIDGE TO TAKE COMMAND OF THE ARMY
OF THE UNITED COLONIES
HE LODGED THAT NIGHT AT THE TAVERN
OF ISAAC BEERS WHICH STOOD ON THIS SITE
EARLY THE NEXT MORNING HE REVIEWED
A COMPANY OF YALE STUDENTS ON THE GREEN
AND WAS THEN ESCORTED BY
TWO COMPANIES OF MILITIA IN UNIFORM
AND A BODY OF CITIZENS AND STUDENTS
TO NECK BRIDGE NEAR CEDAR HILL

ERECTED BY THE CONNECTICUT SOCIETY OF
THE SONS OF THE AMERICAN REVOLUTION
1914

Isaac Beers
Isaac Beers kept his Beers Tavern and bookshop on the corner of Chapel and College Streets; the site today houses one of the oldest bars in the city, built in 1911. His inn was the main meeting place for statesmen when New Haven was co-capital of Connecticut. During the Revolutionary War, his tavern was the site where Benedict Arnold (see page 26) demanded the keys to the powder house; it also hosted George Washington on several occasions. The plaque, shown at left, was taken from the Taft Hotel in 1914. (Above, drawing by Norton H. Peck, courtesy of NHM; left, courtesy of NHM.)

Benedict Arnold

First arriving in New Haven as a merchant and druggist, Benedict Arnold was a born leader. He organized and commanded the 2nd Company Governor's Foot Guard, and when trouble began brewing with the British at the outset of the Revolutionary War, he rose to action. In 1775, Arnold demanded the keys to the gunpowder at Isaac Beers's tavern and marched to Boston to show his support against the British; this is commemorated in a reenactment every year on Powder House Day. He went on to become a valiant general before he sensed his own comrades were unappreciative of his efforts. In 1779, he switch loyalty to the British and became a spy. Arnold fled to England where he died in 1801. As retribution for his actions, his remaining property was taken and his family was shunned. The c. 1905 postcard below shows the Benedict Arnold House on Water Street. (Right, painting by Jonathan Trumbull, courtesy of LOC; below, courtesy of JT.)

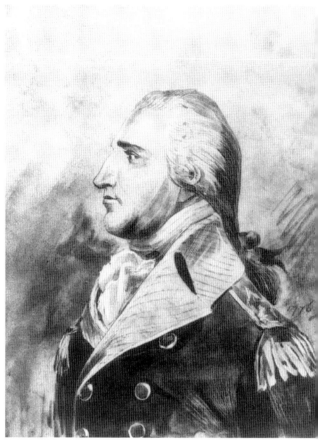

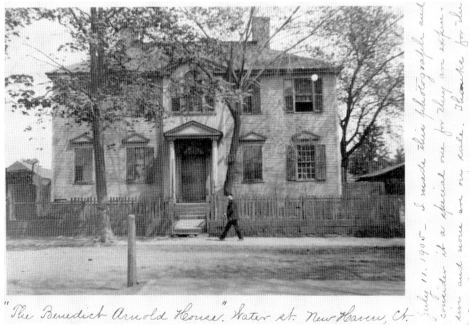

"The Benedict Arnold House", Water st. New Haven, Ct.

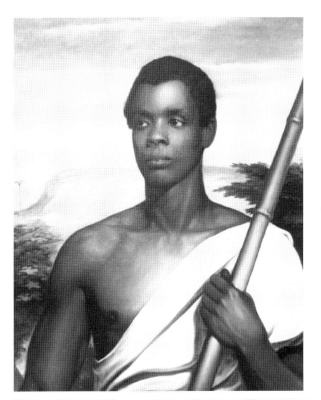

Joseph Cinque

As the leader of the Mende captives illegally stolen from Africa as slaves in 1839, Joseph Cinque led a mutiny on their slave ship *La Amistad*, and the Coast Guard took him to New Haven. The trial, which garnered attention from Pres. John Quincy Adams, ended in 1840 when the slaves were set free and most returned to Africa. The print below is from 1839. (Left, painting by Nathaniel Jocelyn, courtesy of NHM; below, courtesy of LOC.)

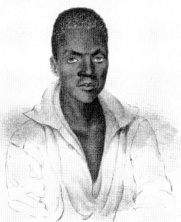

JOSEPH CINQUEZ.

The brave Congolese Chief, who prefers death to Slavery, and who now lies in Jail in Irons at New Haven Conn. awaiting his trial for daring for freedom.

SPEECH TO HIS COMRADE SLAVES AFTER MURDERING THE CAPTAIN &C. AND GETTING POSSESSION OF THE VESSEL AND CARGO

"Brothers, we have done that which we purposed, our hands are now clean, for we have Striven to regain the precious heritage we received from our fathers. We have only to persevere, Where the Sun rises there is our home, our brethern, our fathers. Do not seek to defeat my orders, if so I shall sacrifice any one who would endanger the rest, when at home we will kill the Old Man, the young one shall be saved, he is kind and gave you bread, we must not kill those who give us water.

Brothers, I am resolved that it is better to die than be a white man's slave, and I will not complain if by dying I save you. Let us be careful what we eat that we may not be sick. The deed is done and I need say no more."

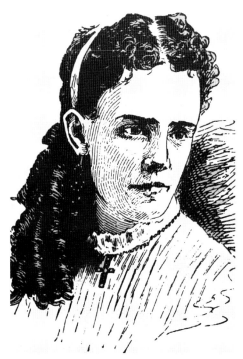

Augusta Lewis Troup

Augusta "Gussie" Lewis Troup, shown in the 1894 drawing at left, was abandoned at infancy and, as a female, stood at a social disadvantage to men. As a girl growing up in New York City during and after the Civil War, she took on the cause to support women's rights. Troup quickly established her name as a major player in women's suffrage, pictured below at a 1916 rally. In 1872, she met her husband, Alexander Troup; moved to New Haven; and founded the *New Haven Union* newspaper. Augusta Troup was involved in every aspect of the paper, and she was considered a pioneer in her journalistic approach. As a labor organizer for workingwomen, she started the Women's Typographical Union No. 1 in 1868 and headed meetings to create female positions on the school board in 1895. Troup's later years were spent living at 389 St. Ronan Street, where she passed away on September 20, 1920. She was remembered as "the Little Mother of the Italian Colony," and a school was dedicated in her name in 1926. (Left, courtesy of NHFPL; below, photograph by Joseph Candee, courtesy of NHM.)

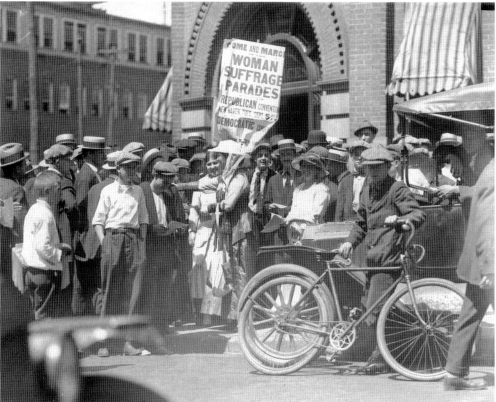

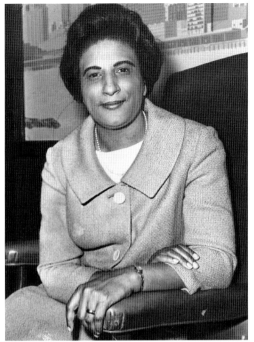

Constance Baker Motley

This New Haven native became the first African American to serve as a federal judge in 1965 after an amazing career in civil rights. She was born ninth out of 12 children, and her mother was the founder of the New Haven chapter of the NAACP. Local philanthropist and contractor Clarence Blakeslee assisted her in her education and encouraged her career aspirations. His house was originally located at 63 Dwight Street but was moved during redevelopment to its present location at 95 Dwight Street. Constance Baker Motley grew up at 8 Garden Street and 54 Dickerman Street. Pictured below in 1966 is Motley with President Johnson. (Left, courtesy of LOC; below, courtesy NHFPL.)

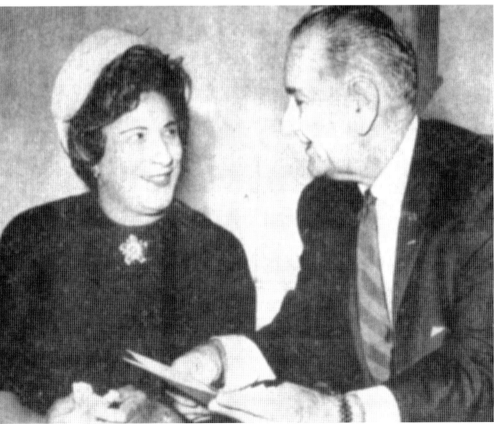

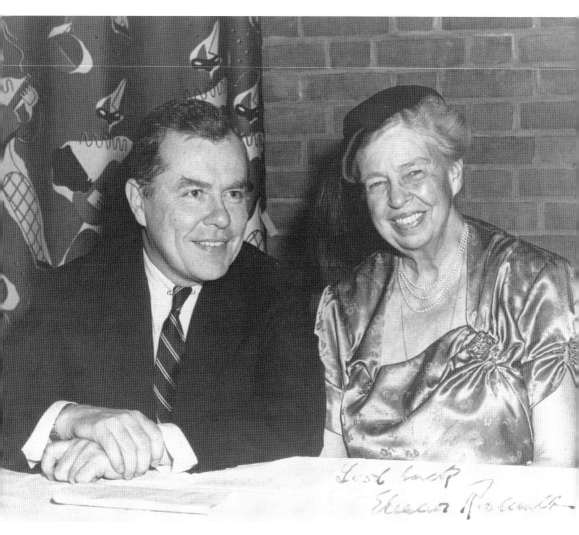

Richard C. Lee

There is not one person who left a greater impact on New Haven's physical landscape than Richard C. "Dick" Lee. Starting from humble beginnings in the Newhallville neighborhood, he rose up the political ranks to become the youngest elected mayor in the city's history in 1953. From that point on, Lee began a process of doing away with slums through the means of siphoning Federal Highway Act grants to the city, more than any other city per capita. Whole neighborhoods like Dixwell, Oak Street, Wooster Square, and Joselyn Square, with mixed ethnicities, factories, and stores, were

obliterated. Swaths of Downtown were taken for a new mall, department stores, office towers, and a coliseum. Many of the changes that Lee helmed have become the bane of urban and community planners, and today, many of his contributions are going through a renewal themselves. Lee served as mayor for 16 years and died in 2003. At left, Dick Lee is seen with Eleanor Roosevelt in 1955. Above is a 1953 photograph of the old Oak Street neighborhood. (Opposite page, courtesy of NHM; above, courtesy of JHS.)

Rosa DeLauro
Rosa DeLauro hails from Italian immigrants who came to the Wooster Square neighborhood. She has been a US representative for Connecticut since 1991 and is one of the most liberal members of the house and also a founding member of the Congressional Progressive Caucus. DeLauro has spearheaded many important issues in the New Haven community and beyond. (Courtesy of Rosa DeLauro.)

CHAPTER THREE

Give Thanks

Generous folks, rich and poor, fill this chapter. James Hillhouse had plenty of land and money, but it is what he did with it all that changed New Haven forever. He began a tree-planting program and created a new cemetery so that people did not just see a field of graves when they went to church. On the contrary, Hannah Gray, a black seamstress, had nothing to her name but a tiny house, which she left to indigent black women. Thanks to James F. Babcock, the editor of a newspaper, the city had its ration of gossip, but Babcock also brought Abraham Lincoln to town when he was running for president.

Mary E. Ives coughed up a lot of her deceased husband's dough to fund a new monumental library, but she had it named after herself. Many do-gooders do not consider ever gaining a reward from their work. George Williamson Crawford was a board member of the housing authority and now has a high-rise apartment building named for him. Paul Russo was probably the wealthiest citizen in the city at one time, but it was only recently that a small park was named for him. It also appeared to be incidental that the Freddie Fixer Day Parade was named for Dr. Frederic Francis Smith, one of it organizers.

It may be no surprise that there are a number of doctors in this chapter, too. Dr. James Paley, who has run a nonprofit affordable housing company, has tirelessly worked to stabilize inner-city neighborhoods while building an office and community that can make a difference. Husband and wife doctors John and Greta Seashore met at medical school and continued to work, live, and raise a family together while they healed hundreds of people. These are the people to give thanks to today.

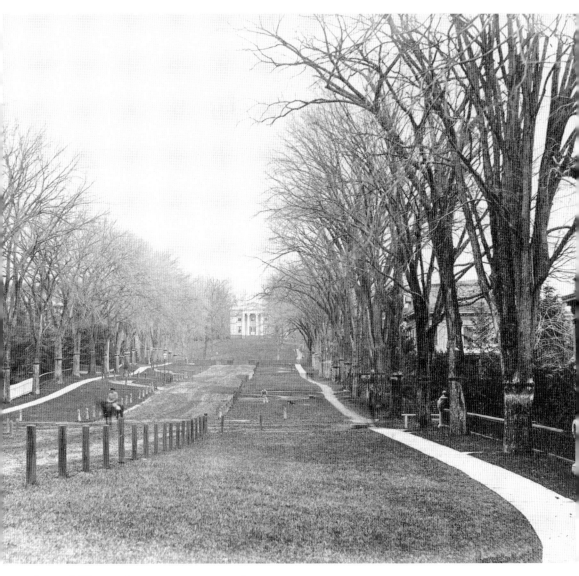

James Hillhouse (ABOVE AND OPPOSITE PAGE)

Arriving in New Haven in 1761 when he was seven years old, James Hillhouse, pictured at left, eventually graduated from Yale College in 1773 and began practicing law. He joined the 2nd Company Governor's Foot Guard and helped protect the city during the British invasion on July 5, 1779. He became a US congressman and senator, and, in 1790, he began to develop land in the northern quarter of town, creating a new street aptly called Hillhouse Avenue. Hillhouse also created the country's first city beautification program by planting elm trees along city streets, later giving New Haven the nickname "the Elm City." He donated land along Grove Street to become the new burial ground, the first family-chartered burial ground in the country. He had darker complexion so people called him "Sachem," meaning "chief" in Algonquin. His son James Abraham Hillhouse built a mansion on the crest of Prospect Hill, naming it Sachem's Wood. This 1870 photograph of Hillhouse Avenue looks toward Sachem's Wood. (Above, courtesy of JT.)

Hannah Gray (ABOVE AND OPPOSITE PAGE)
Hannah Gray was a black laundress and seamstress who gave to the antislavery movement and helped educate poor college students. She was born in New Jersey around 1803. Upon her death on March 15, 1861, at age 58, she was buried in an unmarked grave at Evergreen Cemetery. She left a will stating that the house she owned would be opened to "Indigent Colored Females." A board was established, and the institution was made in her namesake, called the Hannah Gray Home. The home at 158 Dixwell Avenue survived on charitable contributions and was almost foreclosed upon in 1904; however, attorney George Williamson Crawford (see page 40) lowered its annual tax rate by making the home a legal charity. Crawford also helped to sell the old house in 1911 in order to purchase a larger house at 235 Dixwell Avenue; the new house could host 10 residents. The c. 1900 picture above is of 158 Dixwell Avenue, and the c. 1940 picture to the right is of 235 Dixwell Avenue.

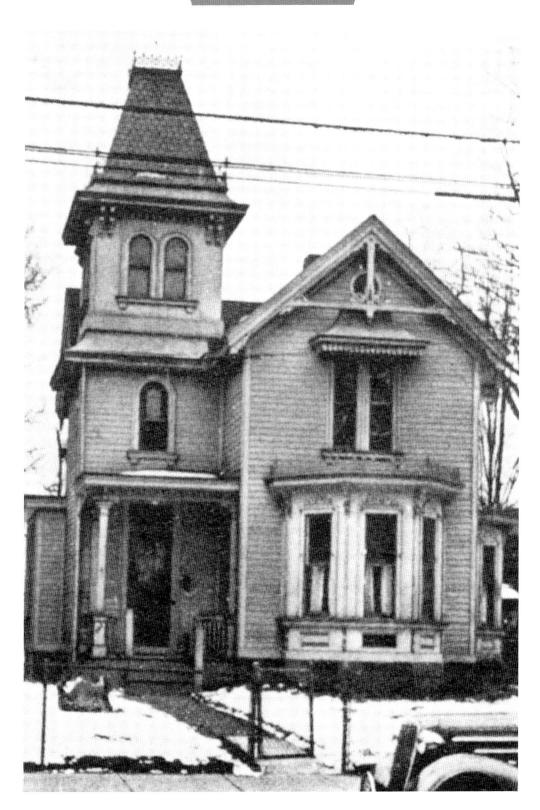

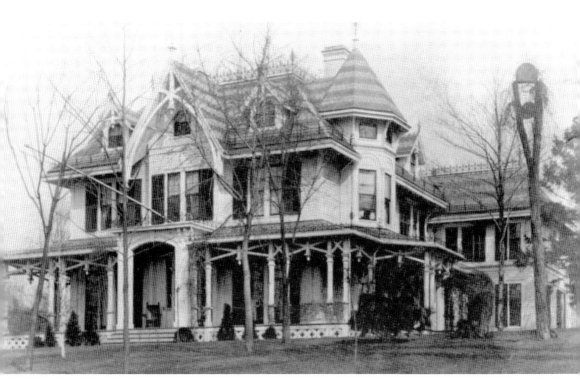

James F. Babcock

James F. Babcock was the editor of the *New Haven Daily Palladium*, the leading newspaper in the state. Babcock was one of the founding members of the Apprentices' Literary Association in 1826, which was an early public membership library, now called the Institute Library; it is the oldest such library in the state. In March 1860, Babcock was the host of future-president Abraham Lincoln at his home on Olive Street during his campaign journey through the state. Like Lincoln, Babcock was a Republican converted from a Whig. Babcock finished building his mansion in Fair Haven Heights on 30 acres of land in 1864, pictured here in 1910. In 1865, Babcock retired from the newspaper, began practicing law, and rose to become the collector of customs and a judge of the county court. Babcock was stricken while in the middle of an arson case and fell from his chair and died in front of the filled courtroom. (Courtesy of JT.)

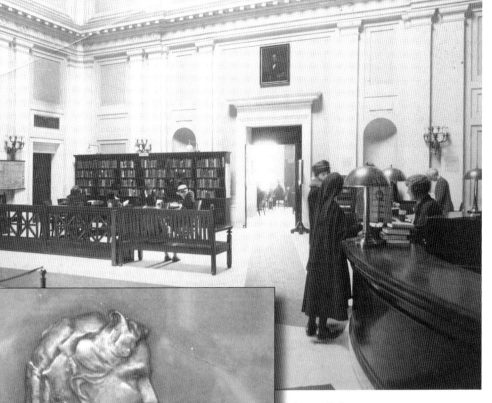

Mary E. Ives

After the passing of her husband, Hobart B. Ives, the head of the trolley system, Mary E. Ives devoted herself to benefiting others. She is best know for helping to plan and fund the New Haven Free Public Library's monumental main branch. Renowned architect Cass Gilbert designed the Neoclassical building in 1908. The library, pictured around 1926, was founded in 1887 and was the fifth public library in the country. Its first books were purchased through a gift from a wealthy French merchant named Philip Marett. (Both courtesy of NHFPL.)

George Williamson Crawford

George Williamson Crawford graduated from Talledega College and Tuskegee Institute and then attended Yale Law School, graduating in 1903. Besides practicing law in New Haven, Crawford was a civic and social leader. He was one of the founders of the local NAACP, and while serving on its board, he was a founder of the Dixwell Community House and was a board member of the New Haven Housing Authority for more than 15 years. In 1953, Crawford became the first black corporation council for the city. He was also a trustee at Talledega College and Howard University. His name lives on in the high-rise apartment building operated by the housing authority, called Crawford Manor. Pictured in 1953 are George Williamson Crawford (left) and Lester B. Granger. (Courtesy of NHFPL.)

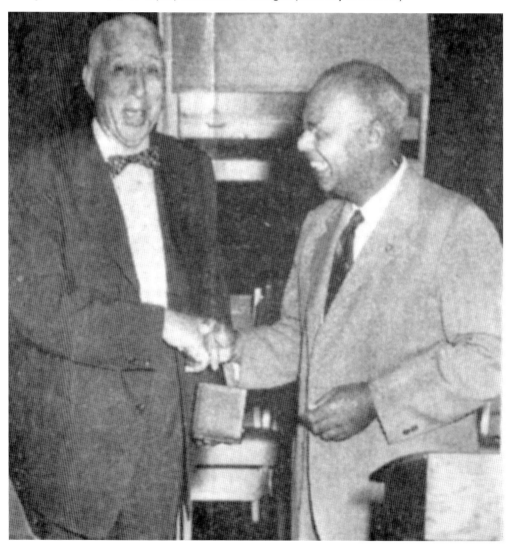

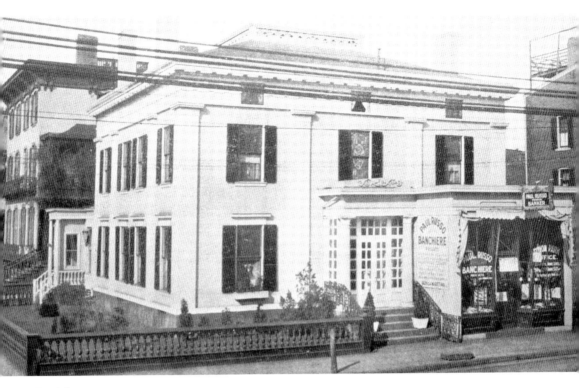

Paul Russo

The son of a talented violinist, young Paul Russo came over from Viggiano, Italy, with his parents. Paul came to New Haven in 1872, making him the fourth Italian to settle here. He played violin and sold peanuts on the streets to help support his family. Russo never attended school, only studying nightly at home. He opened the first Italian specialty store in the state in 1874; it was located on the corner of Congress Avenue and Oak Street. Russo was also called into courtrooms to translate for Italian immigrants, a skill he used for courts as far as New York. In 1882, Russo began a small bank, principally dealing with Italian immigrants. He founded the first Italian Roman Catholic church in Connecticut in 1884, which became St. Michael's, located on Wooster Place. Russo also started the first Italian newspaper in Connecticut, *La Stella D'Italia,* in 1892. His interest in law increased, and Russo was the first Italian to attend Yale Law School, graduating in 1893. For 10 years, he practiced law until he focused entirely on real estate and banking, becoming one of the wealthiest Italians in the city. His real estate holdings included a large tract of land in East Haven called Foxon Park, a name that lives on with a locally produced, family-owned soda manufacturer. Russo passed away at 83 years old in 1942 as the most respected man in his community. A park at the corner of Chapel Street and DePalma Court bears his name. Pictured is Russo's house and bank at 531 Chapel Street in 1921. (Courtesy of NHFPL.)

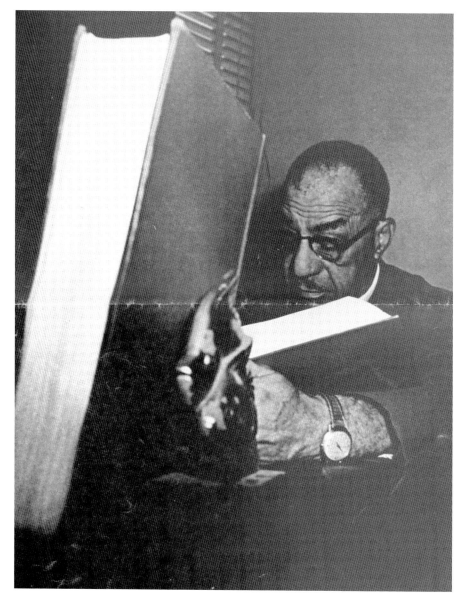

Dr. Frederic Frances Smith

Fred Smith was a prominent African American physician and pediatrician, who strived to make the Dixwell neighborhood free of blight and full of hope. After a lifetime of strife, struggle, and hope, Dr. Smith never stopped believing that he could do more. Dr. Smith was born in Jersey City, New Jersey, on January 30, 1902, and attended Columbia University and Howard Medical School. In 1932, Dr. Smith was desperate to find work as a physician. He was on his way home when he drove through New Haven and made a leap-of-faith decision to set up his practice here. He began practicing medicine that June and located his office on lower Dixwell Avenue in the heart of the black community. Despite the difficulties of creating a new life and facing much adversity, Dr. Smith grew widely successful. He purchased a beach house, raised a family, and became the recipient of an award in 1957 with guest speaker baseball great Jackie Robinson. Dr. Smith continued to be a civic and social leader throughout his life. He passed away in 1979 with his son Fred at his side. (Courtesy of NHFPL.)

"Freddie Fixer"

Dr. Smith's legacy today began on September 15, 1962, when he became one of the lead promoters of a campaign to help elderly residents fix up their properties and clean trash off the streets. A committee came up with the name "Freddy the Fixer" for the event and settled on calling it "Freddy Fixer." New Haven public schools offered a contest to make a fictional character to represent Freddie Fixer. The first Freddie Fixer Parade was held on May 18, 1963, with more than 7,000 onlookers. By 1972, the parade drew 20,000 people, and its grand marshal was Jackie Robinson. The event is held annually in May and brings out thousands of onlookers and participants. The parade route starts on Dixwell Avenue on the Hamden town line and makes its way through the Newhallville and Dixwell neighborhoods. (Both courtesy of NHFPL.)

Neighborhood Housing Services of

Dr. James Paley (ABOVE AND OPPOSITE PAGE)
Dr. James "Jim" Paley arrived to New Haven in the 1970s and saw a city in distress. With his doctorate in housing economics, Dr. Paley started Neighborhood Housing Services of New Haven (NHS) in 1979, a nonprofit housing development company that helps first-time homebuyers purchase homes. Although his organization started small, its mission was also to stabilize neighborhoods to benefit the people who already live there. NHS has grown over the years to employ nearly 30 people. Since Paley hired construction development manager Henry Dynia, NHS has impeccably restored hundreds of homes. Their efforts have helped bring neighbors together as well as take pride in the value of living in such a vibrant community. The author had worked with NHS on and off since high school and participated in Dr. Paley's program by purchasing a house through NHS in which he still dwells. Pictured above is a before-and-after of 33 Beers Street. (Opposite, courtesy of NHS; above, courtesy of NHS.)

Drs. John and Greta Seashore
Meeting as medical students at Yale–New Haven Hospital in the early 1960s, John and Greta Seashore began a parallel medical career becoming masters of their profession. They eventually settled in the Beaver Hills neighborhood and established themselves in the community. John became one of the best surgeons in the area and has served hundreds of patients over the years. Greta has been on the forefront of DNA research and was named one of the top doctors in the country in 2011. (Courtesy of John and Greta Seashore.)

CHAPTER FOUR

Somebody Had To Do It

As the longest chapter, the people included are not only doers but also creators; they are the inventors, builders, designers, planners, tinkerers, and writers. This chapter is entirely male oriented, which corroborates the fact that women, with the exception of a few, were not given the opportunity to hold these positions until late.

Some were born into industrious families and had plenty of backing. Eli Whitney and his nephews Philos Blake and Eli Whitney Blake had plenty of shared capital with which to start. Some of these guys were fresh off the boat and needed to support their families. Max Adler found that he had an adept skill for management, which helped him move up in the manufacturing world. Daniel Visel began with grunt labor but then created his own post office, which spurned other family businesses. James Brewster did not intend to start his carriage business in New Haven, but upon visiting, he was inspired by the ripe potential he saw for a manufacturing establishment.

Not everybody had it easy. William Lanson was a runaway slave who, despite becoming one of the most successful contractors in town, was constantly harassed throughout his life. Samuel F.B. Morse was mortified when he could not get home in time to see his wife before she died; he used that energy to create faster forms of communication. Abel Buell had a rough start when he began counterfeiting money and was caught. He ended up converting that skill to work for the government and made a name for himself in history. John Soto started out poor but worked his way up over the years, and now, he is at the top of his game and is playing it well.

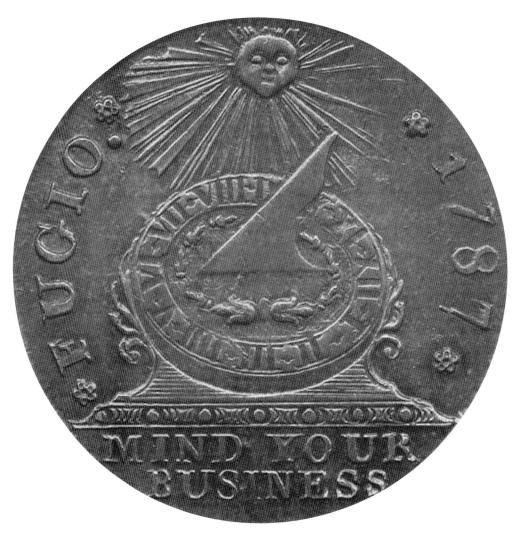

Abel Buell

The story of Abel Buell shows how ingenuity can be both genius and disingenuous. His career began as a silversmith, and he counterfeited money at an early age. When he was finally caught, he received a light sentence and was eventually pardoned. Buell then invented a lapidary machine in 1765 and engraved the first wall map of America in 1783, which was printed in the *Connecticut Journal* on March 21, 1784. In 1785, he invented and built the first coining machine, and it was his dies that made the first minted coin in America, called the copper Fugio or Franklin cent (pictured), designed by Benjamin Franklin in 1787. Buell continued to hold an important role in Connecticut's creative innovation. Unfortunately, he never held onto his own money and died in the almshouse in 1822.

Amos Doolittle

Amos Doolittle was a self-taught engraver who created prints of major battles during the Revolutionary War, including the Battle of Lexington and Concord. He also was one of the first artists to print an American president. In 1794, he printed "The Likeness of George Washington" soon after his successful election campaign. Doolittle also printed presidents John Adams and Thomas Jefferson and New Haven founder John Davenport (see page 11). Doolittle was a member of the 2nd Company Governor's Foot Guard under Benedict Arnold (see page 26) and marched with them to Boston to support the colonists against the British in April 1775. (Courtesy of LOC.)

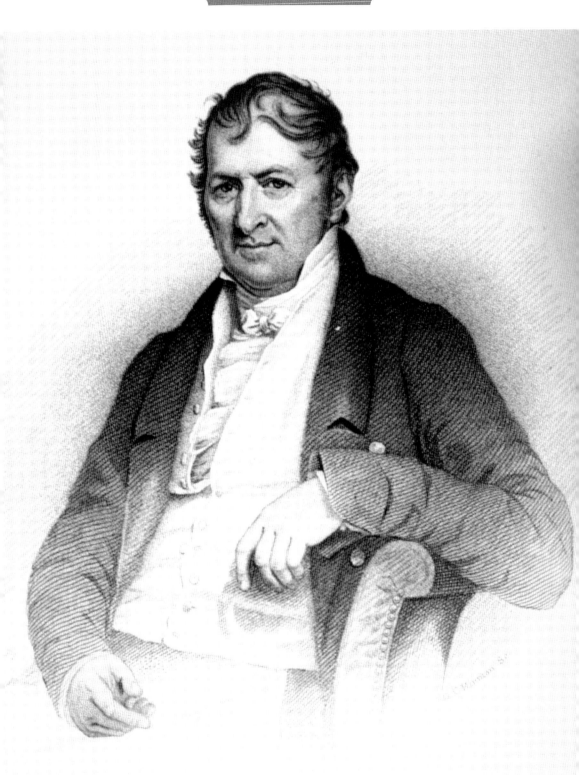

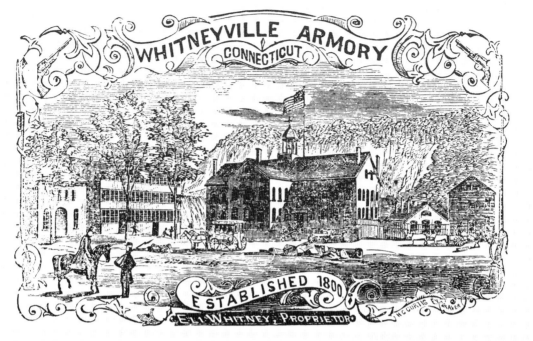

WHITNEY'S IMPROVED FIRE-ARMS

Eli Whitney (ABOVE AND OPPOSITE PAGE)

There is no man considered to be the leader of ingenuity in New Haven more than Eli Whitney. He was smart enough to establish his arms factory on the site of the town's first mill, located at a natural waterfall on the Mill River. Here, in the shadows of East Rock, Whitney invented the cotton gin in 1794. In 1798, he received the first government commission to make firearms where he developed the process of interchangeable parts called the Whitney Uniformity System. Whitney's factories and workers' housing surrounded the millpond, later called Lake Whitney, and the entire area of southern Hamden was dubbed Whitneyville. The Eli Whitney Museum exists at the old mill site and helps children and adults learn from Whitney's craftiness. (Left, engraving by C.B. King and D.C. Hinman; above, engraving by H.C. Curtis, courtesy of NHM.)

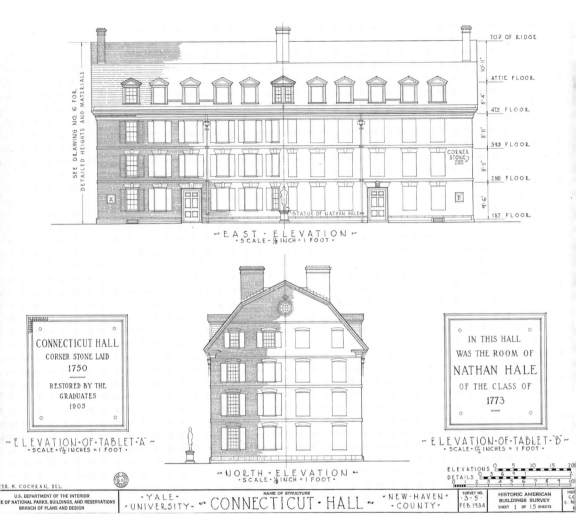

Thomas Bills

Master Mason Thomas Bills built Yale's Connecticut Hall and worked alongside Master Mason Francis Letort and 25 others, including free blacks and slaves. In 1760, Bills purchased a farmhouse and property at 96 Blake Street, now the home of the author. Bills then built the Yale College Chapel, the first chapel built in association with an American university. When the British attacked New Haven on July 5, 1779, during the Revolutionary War, they marched past Bills's house and burned

the family Bible, if not more items. Bills was a gunner in Colonel Lamb's regiment from 1777 to 1781. Upon digging in the backyard, the author discovered a flint stone and lead shot that belonged to a Revolutionary War–era pistol. Bills's daughter-in-law lived in his old house until 1867. Above, 96 Blake Street is pictured in 1983. (Left, drawing by Walter H. Cochran, courtesy of LOC; above, photograph by Dorothy Penar, courtesy of the New Haven Preservation Trust.)

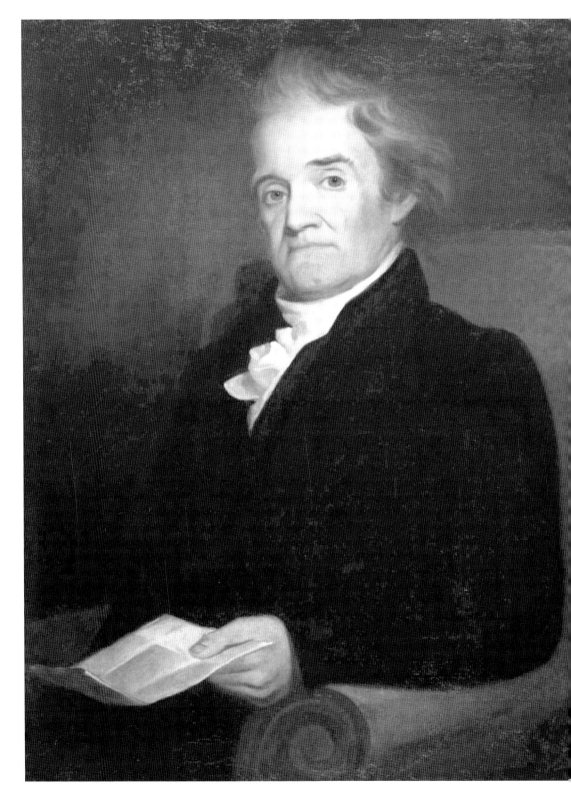

Noah Webster (BELOW AND OPPOSITE PAGE)

Noah Webster enrolled at Yale College at age 16 and studied under Ezra Stiles (see page 12). In 1783, Webster began writing lesson books on the American English language for school children. These were unique because of his belief in this country's separation from England. In 1806, he published his first dictionary. Webster is best known for his *A Dictionary of the English Language,* the first truly American dictionary, written in his house on the corner of Temple and Grove Streets in 1828. Webster's house was going to be demolished for a new Yale College when Henry Ford elected to move it to Dearborn, Michigan, around 1935 as part of his collection of important American history. The Noah Webster House is pictured below in 1934. (Left, painting by Samuel F.B. Morse, courtesy of Beineke Rare Book Library; below, photograph by B.P. Berlepsch, courtesy of LOC.)

10 Dollars Reward.

RUN away from the Subscriber on Saturday night the 7th inst. a Negro Servant named LANSON, about Eighteen years old, tall and strait body, large eyes and lips, prompt and forward in conversation, has a scar plain to be seen near the center of his breast. —He wore away or carried one check'd shirt, one pair of new tow cloth trousers and frock, and a coat and vest made of black and white Wool, mixed, a large felt hat, with a hole in the crown, one bandanno hardkerchief, and one other stamped pocket handkerchief, he has likewise a fiddle with him which he is fond of.—Whoever will take up said Negro servant and return him or secure him and give information, shall receive the above reward and all necessary charges paid by he Subscriber.

N. B. Said Negro was sold from Capt. SILAS KIMBERLY of New Haven, to DAVID DAGGET, Esq. as a servant, until the 19th day of December 180_, and from said Dagget to me the Subscriber.

SOLOMON FISK.

South'ngton, July 9, 1798.

William Lanson

On July 7, 1798, William Lanson, a black slave in Southington, ran away to New Haven to become a free man. Lanson fled with the clothes on his back and his favorite fiddle. Against all odds, he became one of the most prominent contractors in the city and was later known as King Lanson. In 1810, he was the only contractor able to extend Long Wharf into the mud flats in the harbor. The wharf, at three-quarters of a mile long, was the longest pier in the country at the time. Lanson converted an old slaughterhouse on East Street into a hotel, calling it the Liberian Hotel. He also reconstructed old barns in the area as housing for black and Irish families, dubbed New Liberia. He amassed real estate and developed a savvy reputation, owning $40,000 worth of property. Lanson also cared for the sick and poor. Jealous bankers worked to rip his reputation apart, foreclosing on his properties until he lost everything. The Liberian Hotel, which housed mostly indigents, sailors, and railroad men, burned down in 1825. City leaders, like Yale president Timothy Dwight and James Hillhouse (see page 34), respected Lanson and hired him to build the Basin Wharf, Steamboat Wharf, and Tomlinson Bridge. He carried on a livery stable, clothing store, and rooming house at Long Wharf until 1843, when he had a damaging fall. In 1845, after numerous jail sentences for unproven rooming house violations, his son Isaac Lanson wrote a pamphlet pleading for his father's release. On April 23, 1848, a boarder in Lanson's house murdered another boarder, but the city sued Lanson for keeping a "resort of the idle and viscous." Since he could not pay, he again landed in jail. On October 9, he published a pamphlet, *Book of Satisfaction Addressed to the Public*, to vindicate his name. Lanson mentioned that he had been jailed 450 days over a six-year period for various unproven crimes. He died poor and destitute on May 29, 1851, in the almshouse, and despite the local newspaper's harshly worded obituary, the last line read, "He was endowed by nature with more than a common mind." The 1798 article pictured is from the *American Mercury*.

William Lanson's Pier

When William Lanson was hired to extend Long Wharf, he devised a unique method to execute his plan. He realized that building the wharf in the traditional manner of using wooden piers would not work in the shallow mud that existed. He needed to fill in the mud with rock and create a sold and stable pier. Lanson quarried stone from East Rock and brought the boulders to the Mill River, where his crew dumped them into boats. By floating the heavy material and dumping it on site, his plan succeeded in creating the longest pier in the country at that time, pictured in 1896.

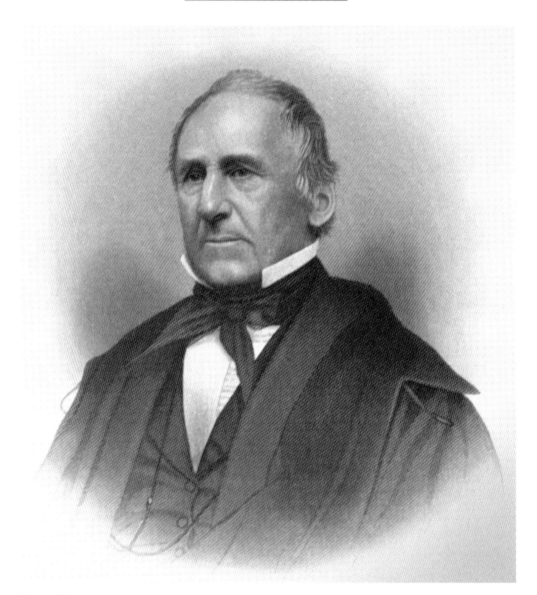

James Brewster
James Brewster was looking to establish a carriage company in New York and was on his way there when his stagecoach broke down in New Haven. While walking around the town, Brewster saw the opportunity to build his company here. He began in 1810 and founded one of the greatest carriage companies, setting up trade in many other states and as far a Cuba. Brewster valued his workers and their education, so he organized lectures by Yale professors for them on popular subjects. Brewster helped establish the first railroad in New Haven, which went between New Haven and Hartford, eventually becoming the New York, New Haven & Hartford Railroad. He died in 1866 from typhoid fever, but his company continued to grow to import and build automobiles. Renowned Yale song man, Cole Porter wrote the song "You're the Top," which mentions the Brewster name in it: "You're the top! / You're a Ritz hot toddy. / You're the top! / You're a Brewster body." (Engraving by W.T. Basher.)

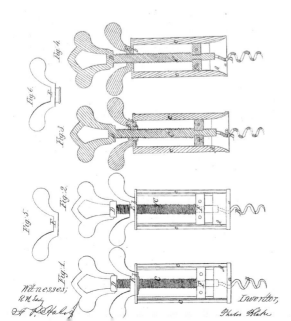

P.Blake,

Corkscrew,

№ 27,665, Patented Mar. 27, 1860.

Witnesses;
R.H. Eddy

Inventor,
Philos Blake

Philos Blake

This inventor was part of the Blake Brothers hardware manufacturers along with John A. and Eli Whitney Blake (see page 60), all nephews to Eli Whiney (see page 50). Philos Blake and his brother John invented a patent for a furniture caster so that heavy tables, beds, and desks could be moved easier. Philos Blake came up with the design for the corkscrew in 1860, allowing a simple twist to open a corked bottle. Prior to this, cork was not commonly used since it was so difficult to extract. Blake's son John built a house on Blake Street in 1840 adjacent to their factory, eventually taking over the operation. (Top, courtesy of NHM; bottom, courtesy of USPTO.)

7945½ X

P., E. W. & J. A. Blake,

Latch,

Patented Dec. 31, 1833.

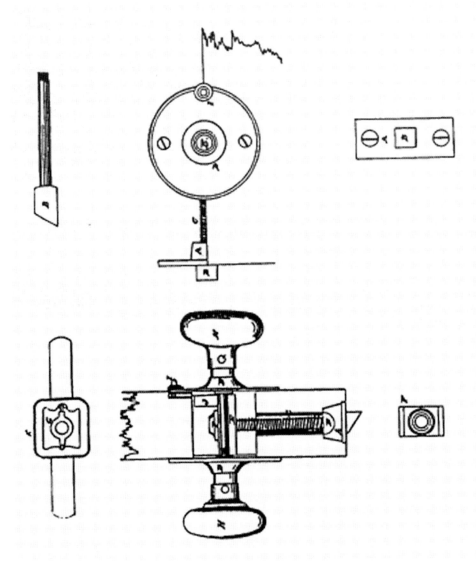

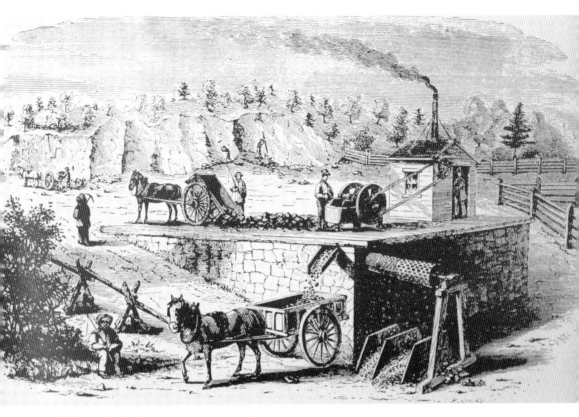

Eli Whitney Blake (ABOVE AND OPPOSITE PAGE)

As inventors go, the Whitney and Blake families were chock-full of them. Eli Whiney Blake was Eli Whitney's (see page 50) nephew and had worked closely with his uncle. In 1830, Eli Whiney Blake and his bothers John A. and Philos (see page 59) joined together to form the Blake Brothers hardware manufacturers. Their mill was on Beaver Brook at the corner of Fitch and Blake Streets. The Blakes were known for their invention of the first mortised door lock in 1833. Eli Whitney Blake also invented the rock crusher in 1858, which he built at the base of West Rock. He was hired to pave Whalley Avenue, the first road in the city to be macadamized, or asphalted. (Opposite page, courtesy of USPTO; above, courtesy of NHM.)

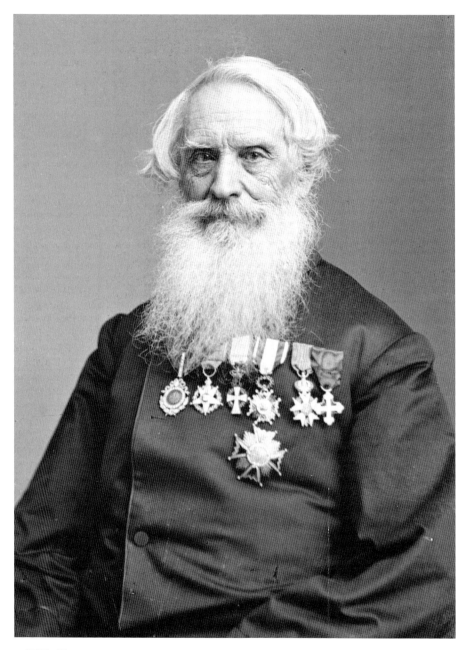

Samuel F.B. Morse

Samuel F.B. Morse came to New Haven to attend Yale; he painted to support himself. After graduating in 1810, he continued painting a roster of portraits, including Noah Webster (see page 54), Pres. John Adams, and Marquis de Lafayette. It was while painting the latter portrait in Washington, DC, in 1825 that Morse learned his wife was gravely ill. By the time he returned home, she had been buried. His grief turned into an interest to increase the speed of communication. He invented the electromagnetic telegraph in 1832, and he later developed the relay signal called the Morse code. In 1840, Morse shot a daguerreotype, or early type of photograph, of the Yale College class of 1810, making it one of the first group photographs ever taken. (Courtesy of LOC.)

Charles Goodyear
This New Haven—bred inventor discovered how to vulcanize rubber into a hard substance in 1843, changing how carriage tires and many other items would be designed. His first license for his patent was to L. Candee & Co. Rubber Shoes and Boots (pictured below) in New Haven in 1844. Employing more than 1,500 hands, this company was the largest rubber boot company in the world. (Left, painting by Nathaniel Jocelyn, courtesy of NHM.)

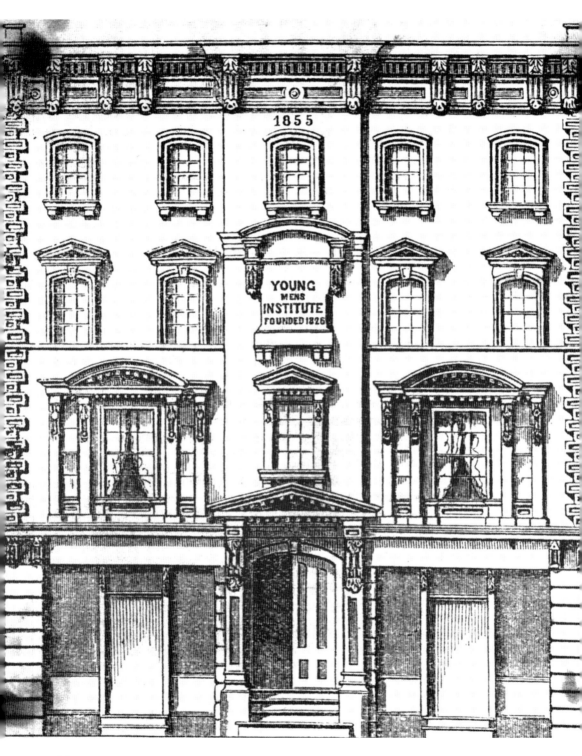

Henry Austin

Henry Austin was one of the city's most prolific architects, designing hundreds of buildings over his 50-year career from 1837 to 1891. One of Austin's earliest remaining commissions was the Yale Library on High Street, which was built in 1842–1845 and designed after an English abbey in the Gothic Revival style. Other works included the 1848 Egyptian Revival–style Grove Street Cemetery gate. The Willis Bristol House on Chapel Street was designed in 1845 and reflects patterns and designs seen in India. He designed the 1855 Italianate-style Young Men's Institute Building, later the Palladium Building, on Orange Street. One of his most visible works is his 1860 High Victorian Gothic–style New Haven City Hall, assisted by his apprentice David R. Brown. (Right, photograph by Hayes, courtesy of NHM; below, photograph by Henry S. Peck; opposite page, courtesy of NHM.)

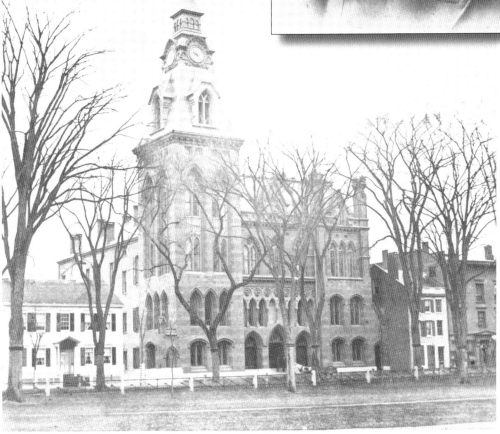

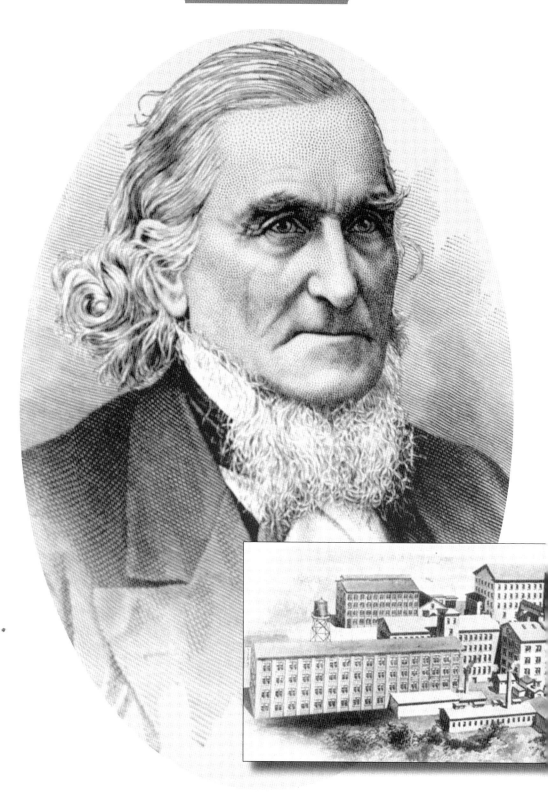

Hiram Camp (BELOW AND OPPOSITE PAGE)

New Haven's enterprising industrial scene has attracted many to bask in its wealth. One such individual was Hiram Camp, who hailed from Plymouth, Connecticut. He left home at age 18 to work at his uncle Chauncey Jerome's clock factory in Bristol. The pair looked to New Haven to open their new operation in 1843. In 1851, Camp built his own factory and two years later, he named it the New Haven Clock Company. After years of expansion, his company became the largest clock maker in the world and employed nearly 500 people. Camp employed his own family member, Walter Chauncey Camp (see page 92), who later took charge of the company in 1902. Hiram Camp passed away at his home on Ferry Street in Fair Haven in 1893. (Opposite, drawing by Herbert R. Smith; below, drawing by Woodbury & Co.)

Max Adler

Max Adler was born in Berkundstadt, Bavaria, Germany, and arrived in America with his parents in 1841. He worked his way up from a young clerk to the manager of a fancy goods store. In 1862, he became manager of I. Strouse & Co., the first makers of corsets outside of France and the inventors of the sewn corset. He remained a partner in the firm, which

eventually was renamed Strouse, Adler & Co. It was one of the largest factories in the city and the largest corset maker in the world, employing 1,500 workers, mostly women and girls. Adler was a leader of his Jewish community and a philanthropist. (Opposite, engraving by H. & C. Koevoetz; below, photograph by Henry S. Peck.)

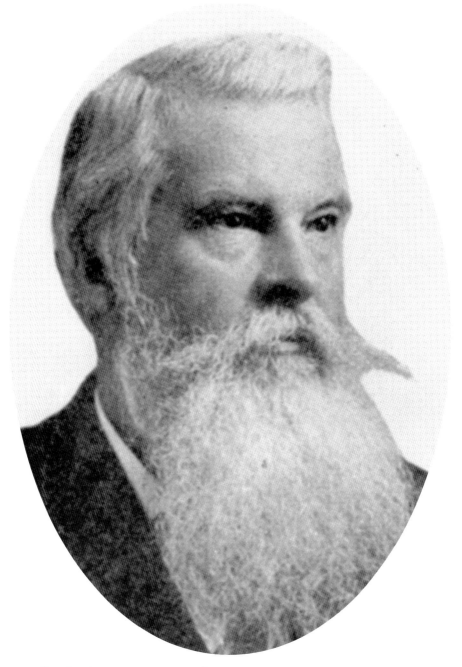

Ebenezer Beecher (ABOVE AND OPPOSITE PAGE)
This inventor was involved in his family match business, using Thomas Sanford's 1834 invention of the friction match. Beecher went on to invent the match-making machine (pictured opposite, top) in 1863, and his company was named the Diamond Match Company in 1870, a name now synonymous with matches. His mansion, called Blondestone, was named for Beecher's favorite light-colored boulder that looked like a dog. He was known as an eccentric who became fearful of others attempting to steal his ideas. (Above, courtesy of USPTO; opposite, top, courtesy of USPTO.)

Witnesses:

Joseph. P. Benton

Mart B. Scott

Inventors:

Anson Beecher

Ebenezer B Beecher

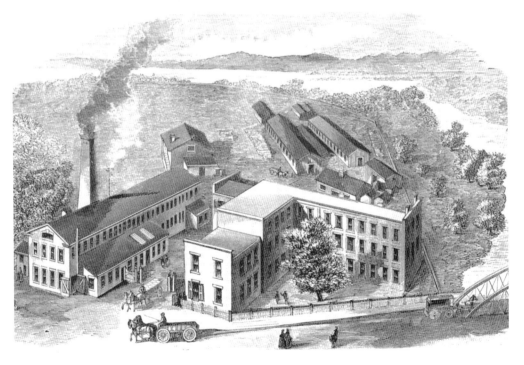

Oliver F. Winchester

Oliver F. Winchester started out making shirts in New Haven in 1855. He changed more than his wardrobe when he began making guns and ammunitions in 1857. Finding a new home near George T. Newhall's carriage company, Winchester set up what would become the largest factory in the city and one of the most famous exports to ever be made in New Haven. Winchester rifles were called "the Gun that Won the West," and at its peak, the factory employed more than 20,000 people, helping to make the Dixwell and Newhallville neighborhoods bustling centers. The plant closed its operations in 2006 and is being redeveloped into offices, laboratories, and housing. (Above, courtesy of the Institute Library; below, photograph by the United Advertising Corp.)

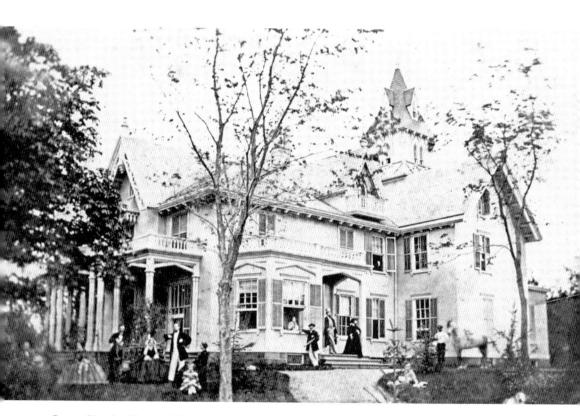

Capt. Charles Hervey Townshend (ABOVE AND OPPOSITE PAGE)
Capt. Charles Hervey Townshend left New Haven in 1848 at 15 years old to helm a ship to the West Indies. He captained ships from New York to Europe, and, in 1867, he began sailing steamboats. Upon returning to New Haven, Captain Townshend discovered that the city's prosperous oyster business could grow by seeding its own oysters locally. His work helped New Haven become one of the oyster capitals of the world. Captain Townshend helped modernize New Haven's harbor and port by organizing the deepening of the ship channel and creating a plan for breakwaters at the mouth of the harbor. Captain Townshend was also highly interested in his own family history (just like family member Doris B. Townshend on page 22), and he added the "h" to his birth name, Townsend, in the traditional English manner. The c. 1865 picture above is of his home, Raynham. (Above, courtesy of JT.; opposite, engraving by H. & C. Koevoets.)

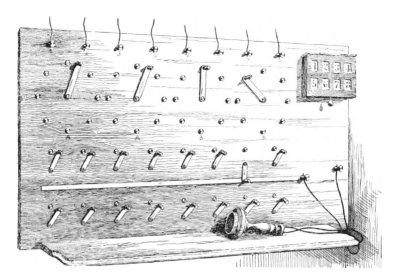

George W. Coy

Credit is due to George W. Coy every time a phone is used. Coy, a telegraph operator, was responsible for inventing the original telephone switchboard in 1877. The above drawing of one was made in 1907. He ventured to an opera house to hear Alexander Graham Bell talk of the wonders of the telephone. Coy went back to his office on the corner of State and Chapel Streets and put together the first switchboard made of carriage bolts, teapot handles, and corset wires. On January 28, 1878, the world's first commercial telephone exchange was created in New Haven, followed by the world's first telephone directory, listing 50 subscribers. All of this attention rang well with investors who created the Connecticut District Telephone Company, changed in 1892 to the Southern New England Telephone Company (SNET). AT&T currently runs all of the city's telephone operations. (Below, photograph by Robert Fulton III, courtesy of LOC.)

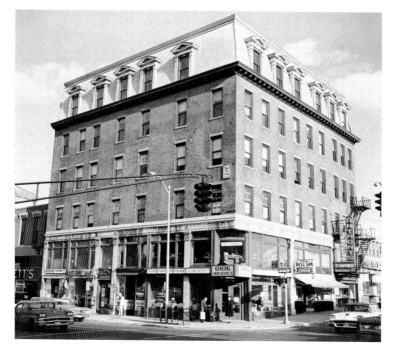

LIST OF SUBSCRIBERS.

New Haven District Telephone Company.

OFFICE 219 CHAPEL STREET.

February 21, 1878.

Residences.	Stores, Factories, &c.
Rev. JOHN E. TODD.	O. A. DORMAN.
J. B. CARRINGTON.	STONE & CHIDSEY.
H. B. BIGELOW.	NEW HAVEN FLOUR CO. State St.
C. W. SCRANTON.	" " " " Cong. ave.
GEORGE W. COY.	" " " " Grand St.
G. L. FERRIS.	" " " Fair Haven.
H. P. FROST.	ENGLISH & MERSICK.
M. F. TYLER.	New Haven FOLDING CHAIR CO.
I. H. BROMLEY.	H. HOOKER & CO.
GEO. E. THOMPSON.	W. A. ENSIGN & SON.
WALTER LEWIS.	H. B. BIGELOW & CO.
	C. COWLES & CO.
Physicians.	C. S. MERSICK & CO.
Dr. E. L. R. THOMPSON.	SPENCER & MATTHEWS.
Dr. A. E. WINCHELL.	PAUL ROESSLER.
Dr. C. S. THOMSON, Fair Haven.	E. S. WHEELER & CO.
	ROLLING MILL CO.
Dentists.	APOTHECARIES HALL.
Dr. E. S. GAYLORD.	E. A. GESSNER.
Dr. R. F. BURWELL.	AMERICAN TEA CO.
Miscellaneous.	*Meat & Fish Markets.*
REGISTER PUBLISHING CO.	W. H. HITCHINGS, City Market.
POLICE OFFICE.	GEO. E. LUM, " "
POST OFFICE.	A. FOOTE & CO.
MERCANTILE CLUB.	STRONG, HART & CO.
QUINNIPIAC CLUB.	
F. V. McDONALD, Yale News.	*Hack and Boarding Stables.*
SMEDLEY BROS. & CO.	CRUTTENDEN & CARTER.
M. F. TYLER, Law Chambers.	BARKER & RANSOM.

Office open from 6 A. M. to 2 A. M.

After March 1st, this Office will be open all night.

77

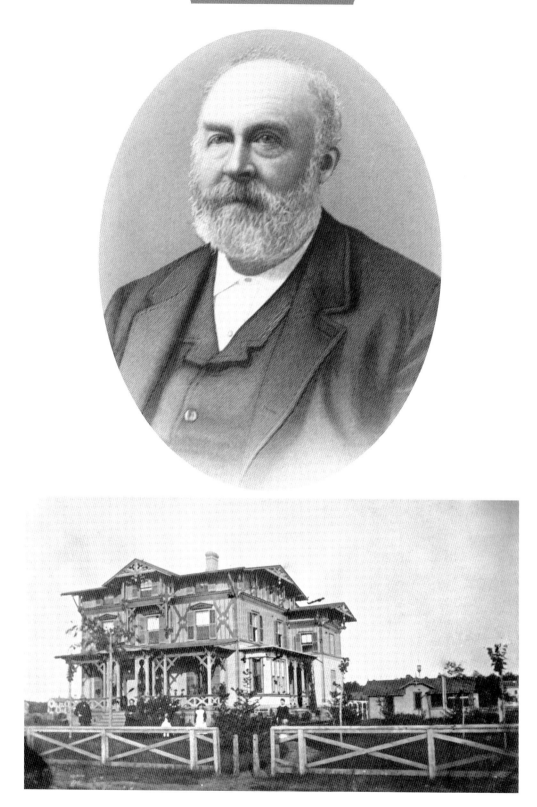

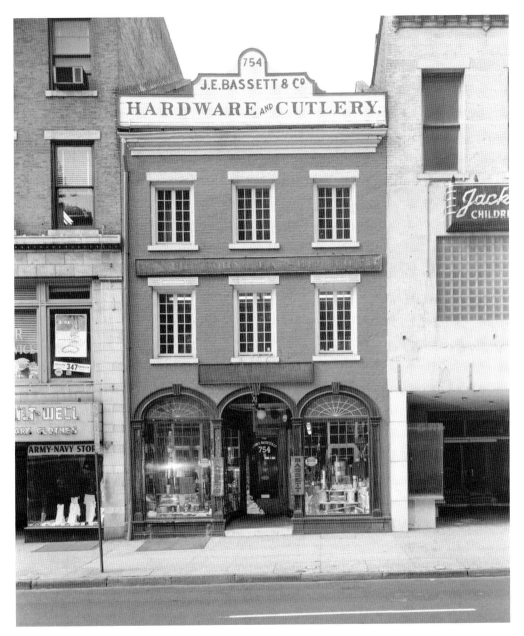

John E. Bassett (ABOVE AND OPPOSITE PAGE)
John E. Bassett was long associated with the hardware store that was founded in 1784 by Titus Street, whose hardware store was one of the oldest in the country. The business changed hands a number of times until 1846, when 16-year-old Bassett became involved. By 1855, he became the sole owner, and the business name was changed to John E. Bassett & Co, a name that existed until the store closed in 1973. A large Stick-style house was built for Bassett on Shelton Avenue in Newhallville, designed by Henry Austin (see page 64), around 1865. Bassett developed tracts of land around his home, and one of the main streets, Bassett Street, is named for him. He died at his home on January 12, 1896, after complications with malaria. (Above, courtesy of LOC; opposite top, engraving by H. & C. Koevoets; opposite bottom, courtesy of NHM.)

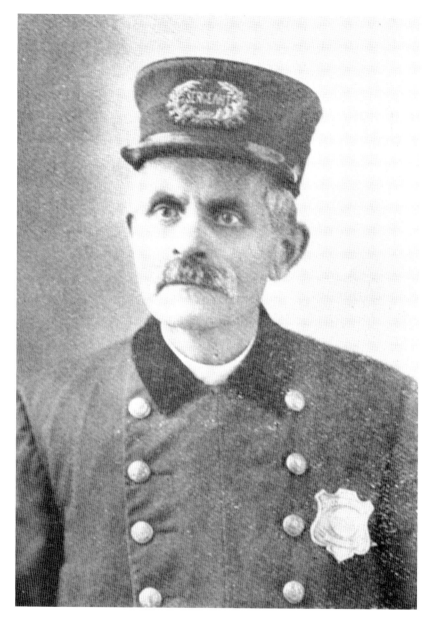

Sgt. John Driscoll

This Irish immigrant became a police patrolman in 1871, and by 1887, John Driscoll was promoted to sergeant. Driscroll, pictured in 1903, was an expert at shutting down gambling houses, brothels, and after-hours joints and chasing and capturing thieves. One of his hunches came through on November 18, 1888, when he busted a Chinese opium den and gambling house on Crown Street. The most humorous episode happened on November 10, 1879, when a Scotch terrier grabbed hold of Sergeant Driscoll's nightstick at headquarters and took off. Other officers and bystanders witnessed the frightened dog being chased around. Sergeant Driscoll was in hot pursuit when the dog ran through an open window and down the street, completely outrunning the cop. In 1890, he became the inspector of public vehicles to combat dangerous cab drivers. Sergeant Driscoll passed away at his house on Nash Street on November 4, 1910, at age 68, still working six weeks prior to his death.

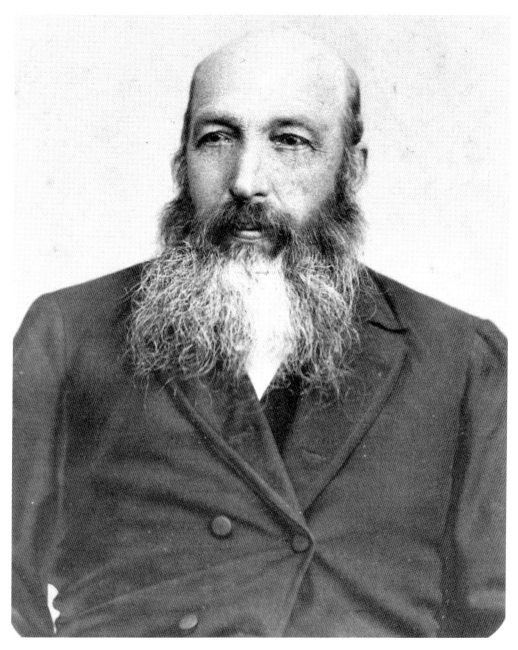

Daniel Visel

Daniel came to New Haven from Remmingsheim, Germany, in 1848 and began working as a carriage builder. Visel eventually ran a grocery store and moved to Hamden near the New Haven line around 1870. In 1888, he established a post office and called the area Highwood, due to the tall trees that he could see nearby. Visel's family built homes and businesses in the area, and his son-in-law Philip Doppensmith built a drugstore on the corner of Dixwell Avenue and Bassett Street, naming it Visel's. Although the family has entirely moved out of the area and does not own the business, their name still adorns the busy corner, and hundreds of customers must wonder who the store was named after. (Courtesy of the Visel family.)

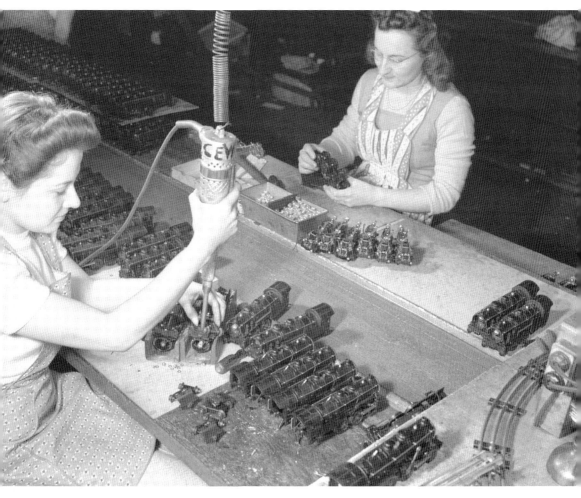

Alfred Carlton Gilbert (ABOVE AND OPPOSITE PAGE)
Alfred Carlton Gilbert, known as A.C. Gilbert, came to Yale and became a star athlete, setting world records and achieving a gold medal in the Olympics in 1908. In 1907, he cofounded Mysto Manufacturing with John A. Petrie on Valley Street in Westville. In 1913, Gilbert established the A.C. Gilbert company, making toys and the first Erector Set, the longest running toy line. When the US government tried to put a ban on toy making in 1918 during World War I, Gilbert protested and continued to build toys. He was called "the man who saved Christmas." Besides the Erector Set, seen at left in a 1941 advertisement, Gilbert's company made chemistry and microscope sets, and in 1938, it began making American Flyer train sets. He was generous and kind and set up a fun and safe work environment at his Fair Haven factory on Peck Street. Gilbert was also one of the founders and the first president of the Toy Manufacturers of America. He had a large estate in north Hamden called Paradise, and he wrote an autobiography titled *The Man Who Lives in Paradise*. (Above, photograph by Howard R. Hallem, courtesy of LOC.)

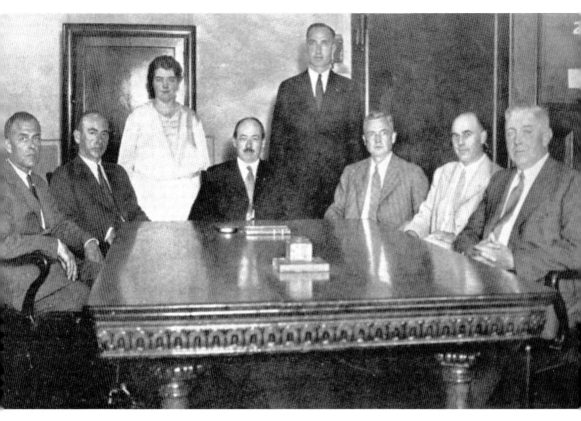

John Hancock Tweed

"Mr. New Haven Airport" was a title given to John "Jack" Hancock Tweed, the organizer of New Haven's first airfield and municipal airport. He was an early flyer and was the third person in the state to have a pilot's license. In 1925, Tweed began service at the New Haven Air Terminal in the Morris Cove neighborhood, crossing into East Haven. In 1926, Tweed helped stage the first seaplane at the

field. He became the manager of the New Haven Municipal Airport 1931, which had its first commercial service flight in 1933. In 1961, Tweed died, and the airport was dedicated to his service, being named to this day the Tweed-New Haven Airport. The airport continues to have commercially operated passenger service, one of only two airports to offer this in the state. Pictured at left in 1931 is the airport commission. (Opposite, courtesy of the NHFBL; above, courtesy of JT.)

John Soto

Connecticut has long been a manufacturing center for the defense industry, and John Soto began his company Space-Craft Manufacturing in 1970. His life started out poor in Fajado, Puerto Rico, where Soto was determined to progress and never give up. For 20 years, he worked at machine shops, learning skills and establishing relationships. When Soto first started the company, it worked on gas turbine engines, but it has become one of the leading companies in the United States making precision parts for aircraft and land-based engines. In 1993, Soto relocated the company to larger facilities in New Haven. Some of their clients include Sikorsky Aircraft, Pratt & Whitney, and the US Air Force. As a family guy, Soto's son Pedro works with him as a general plant manager. John Soto considers giving people the opportunity and training for success of utmost importance, and he has set up scholarships to achieve that goal. (Photograph by Lisa Wilder, courtesy of *Business New Haven*.)

CHAPTER FIVE

Extracurricular

Extracurricular activities, like art, sports, music, and drama, take place after school, work, or before bedtime, and the people in this chapter were largely connected with these creative ventures.

To make a living off art was just as much of a challenge in the past as it is today. George Henry Durrie was a prolific artist and was extremely talented. He was known for being self-taught. Donald Grant Mitchell wrote novels and essays throughout his life. He was also able to take on other professions, and he had plenty of money so he did not need to worry about selling books. It was his sense of peace that led him to writing and the expression of his artistic self. Winfred Rembert started to make art later in his life, which helps him cope with the trauma of his past.

Using the arts as a business model worked for many in the past. Architects combined drawing, mathematics, engineering, and psychology to produce working and living places. One master of this field included Ferdinand Von Beren, who used simple techniques to make buildings comfortable. Sylvester Z. Poli was a theater mogul who promoted dramatic arts into the age of film. Even as a business owner, he never lost sight of the pleasure that goes into making an idea come alive. Rufus Edward Greenlee was a vaudeville performer who, upon retirement, opened a jazz club. His desire to entertain never ceased, but the way he presented it changed with his life. A legend, Walter Chauncey Camp never let his athletic skill or strategizing stop him from entering the family business, and he excelled at all he did.

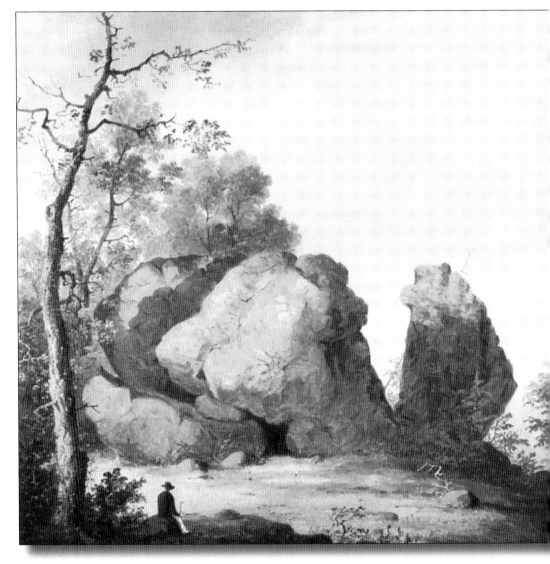

George Henry Durrie (ABOVE AND OPPOSITE PAGE)
This prolific self-taught artist came to New Haven from Hartford as a young man. He received instruction from Nathaniel Jocelyn, a prominent local painter. Durrie's paintings showed landscapes and rural scenes throughout the Northeast. A number of his prints popularized when Currier and Ives published them as lithographs. Above is an 1853 painting of Judge's Cave (see page 24) by Durrie; opposite is a self-portrait of George Henry Durrie.

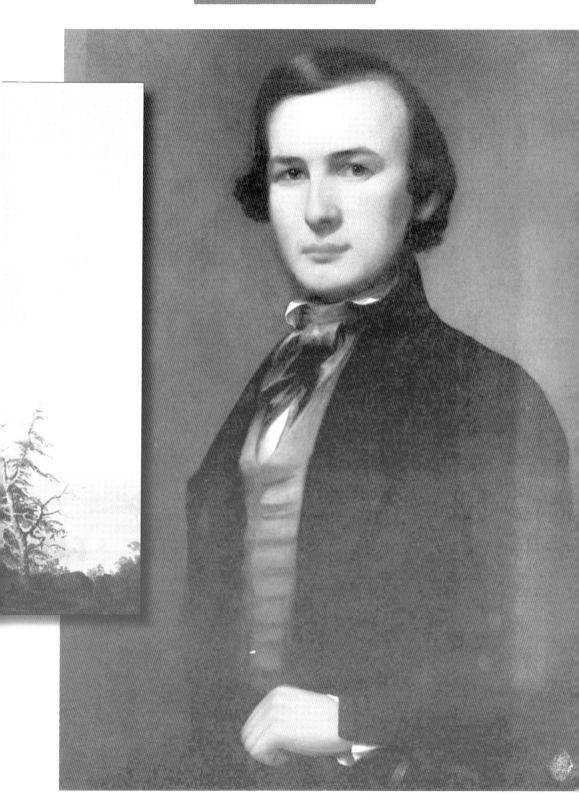

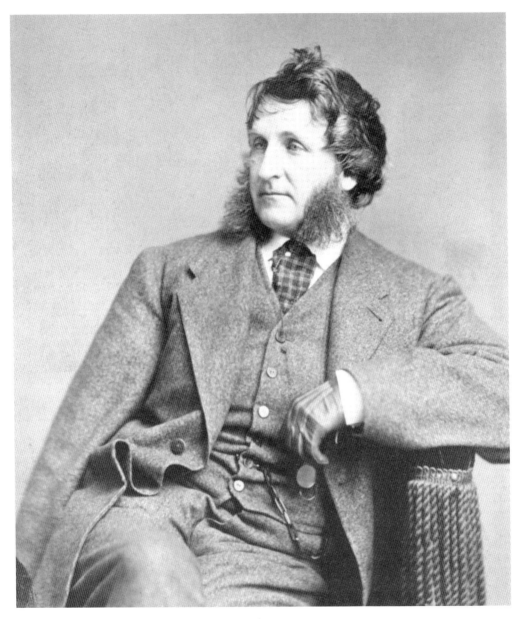

Donald Grant Mitchell (ABOVE AND OPPOSITE PAGE)
After graduating from Yale in 1841, Donald Grant Mitchell began to write essays and novels under the pen name Ik Marvel. He served as the US consul to Venice, Italy, and then returned to America in search of the perfect farm. He came back to New Haven by train in 1855 and found his future home on Forest Road, then called Rosebank. Mitchell had a great interest in natural habitats and agriculture, mapping and laying out scenic paths and views throughout his large estate, as seen in the 1868 lithograph at the top of the opposite page. He renamed it Edgewood as it was at the edge of the woods. Marvel began the original designs for many of the city's first parks including East Rock, Edgewood, and Bay View. He died on December 15, 1908, but his legacy continues with the Mitchell Memorial Library, and the many roads named for him. (Above, photograph by Rockwood; opposite top, by Major & Knapp Co.; opposite bottom, photograph by Rockwood.)

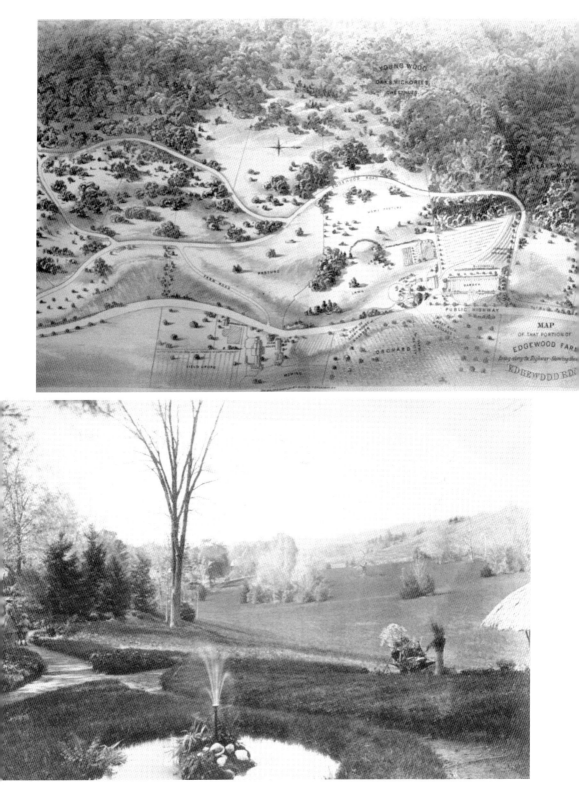

Walter Chauncey Camp
Dubbed "the father of American football," Walter Chauncey Camp attended Yale where he played and captained the football team. At the time, football was closer in rules and style to rugby. Beginning in 1880, Camp began to introduce changes that would create modern American football, including the system of downs, the line of scrimmage, the point system, and field positions. He was the football coach at Yale from 1888 to 1892 and wrote prolifically about football. Camp eventually worked for his family's clock business, the New Haven Clock Company, and became its general manager in 1902. He helped streamline the business and introduced the production of wristwatches in 1915. (Top, courtesy of LOC; bottom courtesy of YMA.)

Ferdinand Von Beren

Germans were attracted to New Haven's business life, and young Ferdinand Von Beren came along for the ride with his parents from Hanover, Germany, in 1875. By 1886, Von Beren began an illustrious career as an architect, working with David R. Brown. They formed a partnership called Brown & Von Beren in 1900, and their designs went into hundreds of buildings in every corner of the city. Von Beren designed many important buildings in the city, including almost every schoolhouse in the first quarter of the 20th century. He designed the larger movie theaters, banks, social clubs, department stores, and numerous houses of all sizes. Many of Von Beren's works that remain today stand out in quality from other designs and continue to leave his mark on the city. Pictured at the left is a detail of Von Beren's house, and at the right is the Liberty Building in 1905.

Sylvester Z. Poli
Hailing from Bolognano, Italy, with barely a penny in his pocket, Sylvester Z. Poli, pictured at left in 1920, came to the Oak Street neighborhood, New Haven's melting pot in 1882. In 1907, he began a career of owning and operating vaudeville and moving picture theaters in the city. By 1910, Poli owned 28 theaters throughout the Northeast. His flagship theaters included Poli's Palace, the Bijou, Poli's College Street in New Haven, Poli's Palace in Waterbury, and Poli's Majestic in Bridgeport. Poli built a mansion on Howe Street but wanted to live near the working-class people of Oak Street, many of whom were his theater-going customers. He was never fully accepted by the native-born Yankees, and he endeavored to create opportunities for immigrants from all backgrounds. The c. 1905 photograph below is of Poli's Theater on Church Street.

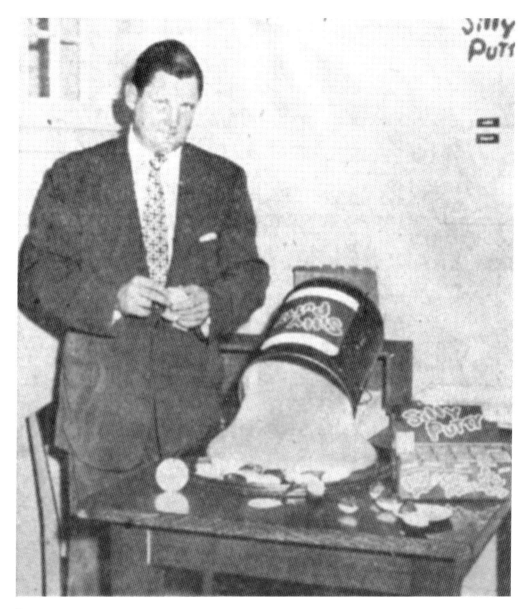

Peter co.

By taking a glop of silicon and marketing it as a toy, Peter Hodgson created one of the most popular items ever for kids—Silly Putty. Silly Putty was born in 1949 when Ruth Falgatter, the owner of the Block Shop, a toy store, had Hodgson over, and he noticed the strange substance in a pile. He took it home with him and noticed how it attracted people's attention. Hodgson said, "It began to get in the way. It interrupted conversations, some pretty important conversations sometimes." J.G.E. Wright, a chemist looking for a replacement for rubber at General Electric during World War I, first created this substance. To help sell and distribute, Hodgson employed at first Yale graduate students and then enlisted William Henry Haynes, a black man who worked at the Block Shop. Haynes also called on his entire family to help out when production took off. The factory was later set up in North Branford around the time that Silly Putty became a global product in 1961. Hodgson died in 1976, and the company was sold the following year. (Courtesy of NHFPL.)

Rufus Edward Greenlee
Rufus Greenlee was a vaudeville performer and, later in life, a popular club owner (pictured at right in the top image and pictured below). He was born to a well-to-do family on November 23, 1893, in Asheville, North Carolina. The family moved to New Haven and then to New York City. Greenlee's early life was spent working with traveling minstrel acts as well as at a saloon on Coney Island in 1909. Due to his collegiate-style dress, he was dubbed "Rah! Rah!" Greenlee also danced with a couple of dance companies, and once shared a bill with newcomer Charlie Chaplin. Greenlee joined up with fellow dancer Teddy Drayton (pictured at left in the top image), calling themselves the Colored Aristocrats. The pair toured 14 countries in Europe in 1913 with another African American duo, Charles Johnson and Dora Dean, and returned to New York. In 1914, Greenlee and Drayton began gracing the stage with their act. Their formal dress and elegant dance moves gave their art the name "picture dancing." In 1923, they performed at the Cotton Club in New York City; in 1926, they performed for Stalin in Russia and more. They broke up around 1930. Greenlee and Drayton are considered the first "class act" that paved the way for later vaudeville, tap, and stage performers. (Top, courtesy of NHFPL; bottom, photograph by Danny Kato.)

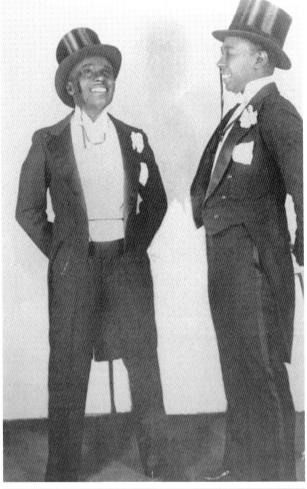

LACK COFFEE
OHNNY "HAMMOND" SMITH
RIO - PLUS SELDON POWELL
rded "live" at the Monterey Club—New Haven, Conn.

Rufus Edward Greenlee's Club

Greenlee retired to New Haven and opened the Monterey Club in 1936, moving it to 265–267 Dixwell Avenue by 1941. During the next 20 years, this club was the main stop for Jazz greats between Boston and New York. Some of the greats who played the Monterey include Duke Ellington, Billie Holiday, Charlie Parker, and John Coltrane. Greenlee passed away on August 21, 1963. Teddy Drayton attended the funeral of his partner and best friend of 50 years and said, with pride, "You'd have thought they were burying the mayor of the city." (Above, courtesy of NHFPL.)

97

Thornton Wilder

This intellectual and prolific playwright and writer came to Yale to study, graduating in 1920. Thornton Wilder befriended his teacher Jack Crawford, who was instrumental in the building of the Little Theater on Lincoln Street in 1924. Later, Thornton lived with his mother and sister on Mill Rock in Hamden, overlooking New Haven, where he died in 1975. His best-known works for which he won Pulitzer Prizes are *The Bridge of San Luis Rey*, *Our Town*, and *The Skin of Our Teeth*. (Courtesy of LOC.)

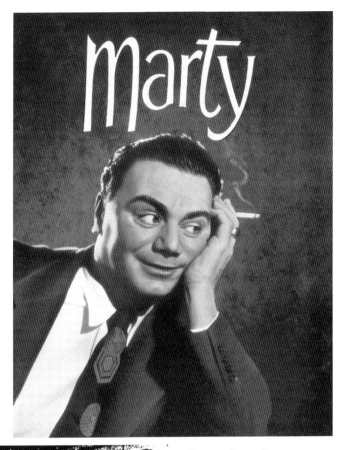

Ernest Borgnine

Ernest Borgnine was the son of Italian immigrants, originally named Borgnino, who lived in Hamden and then moved to 285 Bassett Street in 1942. When Bornine returned from fighting overseas during World War II in 1945, he was without purpose. That did not cut it for his mother, and Borgnine's forward humor and wit inspired her to suggest that he go into acting. He began studying in Hartford, then Virginia, and finally Broadway. In 1951, Borgnine moved to Los Angeles, and in 1956, he won the Academy Award for Best Actor for his role in *Marty*. Borgnine starred in numerous movies and television shows, best known for *McHale's Navy* and *Airwolf*. He passed away on July 8, 2012, leaving behind evidence of one of the longest acting careers in history. Above is a poster for the film *Marty*; at left is an article showing Bornine's father, sister, and her family in 1956.

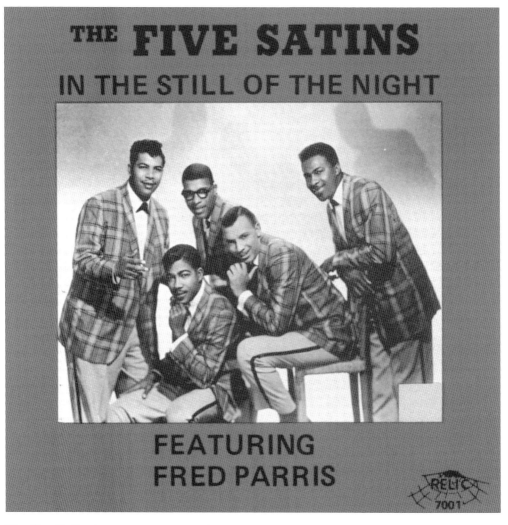

The Five Satins (ABOVE AND OPPOSITE PAGE)

New Haven had its share of doo-wop bands in the 1950s, and the best-known group of them was the Five Satins. After the group began in 1954, it continued with members Fred Parris, Ed Martin, Jimmy Freeman, Nat Mosley, and Al Denby. They recorded their most-famous song "In the Still of the Night" in 1956 in the basement of St. Bernadette's Church on Townsend Avenue. The song first landed on the B-side of "The Jones Girl," but when Ember Records picked up the song, it went flying up the charts. The song made No. 3 on the R&B charts and was No. 25 on the pop charts, selling more than one million records. In 2003, the Five Satins were inducted into the Vocal Group Hall of Fame. Fred Parris is pictured at right in 2007. (Right, courtesy of Debra Marafiote.)

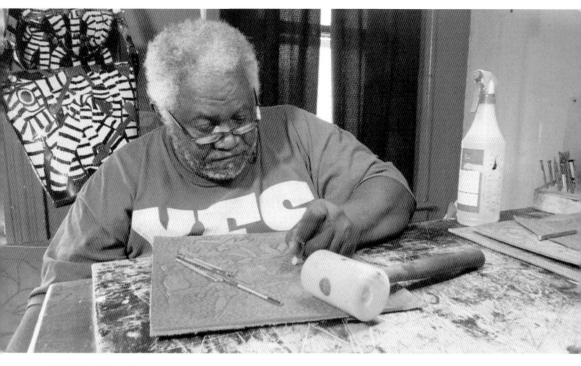

Winfred Rembert

Artist Winfred Rembert manipulates leather to feature his stories of growing up black in the rural South. Rembert was born in 1946 in Cuthbert, Georgia, and was abandoned as a child. He lived with his aunt and worked on cotton fields, leaving only two days per week to attend school. He never learned to read or write, and by 13, Rembert was having fun dancing at pool halls and juke joints. His life changed when he joined a sit-in that became a violent scene with mobs of whites chasing blacks and beating them. Rembert escaped by stealing a car but was later caught and jailed for a year. After the sheriff abused him, he escaped; however, he was again caught and hanged upside down on a tree and beaten. He was spared death, and in 1967, he was sentenced to 27 years working on a chain gang, picking cotton and digging ditches. Enduring this period of agony, Rembert met his future wife, Patsy, while working outdoors. His good behavior let him to return to society in June 1974. While in prison, Rembert learned to work with leather, so when his wife suggested that he create a more permanent way to share his life's stories, she imagined that he could use the leather as the art form. In 1996, he began creating his leather pieces, each one taking about a month to make. Rembert has received national acclaim from his work and the amazing story of a country boy who made it. (Courtesy of Ducat Media.)

CHAPTER SIX

Feeding the Masses

New Haven has had a lot of mouths to feed, so this chapter is dedicated to a few of the legendary families, stories, and people who brought something to the table. The city's cuisine has always been a reflection of those who have lived here. In many cases, the recipes have adapted to the locale, and that is what gives New Haven such a definitive dining experience. Besides, this town used to be home to the Culinary Institute of America.

To help wash down the food, a good drink is always needed. When George Anton Basserman started brewing his beer, there was an immediate customer response. That is not to say that there were no other brewers here before him, but each brewer had his or her own technique and taste, and it did not hurt that Basserman had terraced party decks behind his brewery.

A uniquely New Haven tradition began here when Louis Lassen created the first hamburger sandwich ever recorded. His tiny little shack was saved from the wrecking ball and moved to its current location due to the overwhelming impact Louis' Lunch has had on this town and beyond. Archie Moore ran a saloon that was carried on by his family and then others. The restaurant is still called Archie Moore's, a name that is second nature to so many in this area. Harry Lender began baking his bagels in small batches well before Lender's Bagels became an international sensation.

Pizza is the real story here in New Haven. With the influx of so many Italian immigrants, it was no wonder that of all the foods that took hold of the city, pizza has outlasted and out baked every other dish. Frank Pepe started his operation small, but it became an instant hit with everyone. Sally and Flo Consiglio opened their pizzeria just down the street, as did others. The city supported all of them, but it is clear that only the strongest families and the best pizza survive still today.

New Haven also has had a lively culinary rebirth. Restaurants have clustered in and around the downtown area, creating multiple districts that attract people from near and far. Some of these restaurants have been making national news, and one in particular, Miya's, run by mother and son Yoshi and Bun Lai, has transformed people's attitude and understanding about food and food culture.

ROCK BREWERY,
Foot of East Rock, New Haven, Conn.
owell, Photographer.
GEORGE A. BASSERMAN, Proprietor.

George Anton Basserman

Coming from Hesse-Darmstadt, Germany, 15-year-old George Anton Basserman created a new life in America in 1847. He was a butcher and established a meat market downtown on Church Street. In 1851, Basserman returned to Germany and came back with a wife, Johanna. During the Civil War, he fought with in the 2nd Regiment, reaching the rank of colonel. With the help of his son Charles, Basserman began a brewery in 1868 at the base of Snake Rock, part of East Rock. He named it the Rock Brewery, building it from local stone. He quarried tunnels in the rock to store beer, used spring water to brew. and built beer garden terraces along the slope of the rock. The brewery became one of the most popular in the city. It also incorporated steam power and an artificial ice machine. Basserman was savvy and quick to execute his decisions. After a disagreement with the land owner right before his land lease expired, he hired 50 men to tear down the building starting on Saturday, April 29, 1871. By Monday, May 1, all that was left on the site was a large hole, and he found use for the rubble elsewhere. Basserman was also extremely generous with his beer and never objected to a sale. He found himself in front of the liquor commission numerous times, never fully accepting their authority. At nearly 55 years, old Basserman died on September 27, 1887. The undertaker claimed that he never saw a corpse look so peaceful and lifelike, so much so, that Basserman's daughter asked, "Is he dead?" Two days later, the city experienced one of the largest funerals in its history. The procession, consisting of the 2nd Regiment, the city battalion, firemen, policemen, friends, workers and family, began at the armory on Meadow Street and headed up to his house on State Street. Then they followed the hearse to Evergreen Cemetery where Basserman was buried next to his wife. A looming storm lay overhead, but no rain fell, and it was recalled that this same storm occurred at the passing of his wife in 1878. (Photograph by George E. Cowell, courtesy of NHM.)

Basserman Mansion
Basserman built a notable stone mansion close to his brewery on the corner of State Street and Rock Street. It was the largest house designed in that part of town, which was called Cedar Hill. The house, in the Stick style, had elements that evoke Medieval German architecture. It was built of local stone from Snake Rock, an extension of East Rock. His views looked over the Quinnipiac River meadows. (Engraving by W.E. Hopson.)

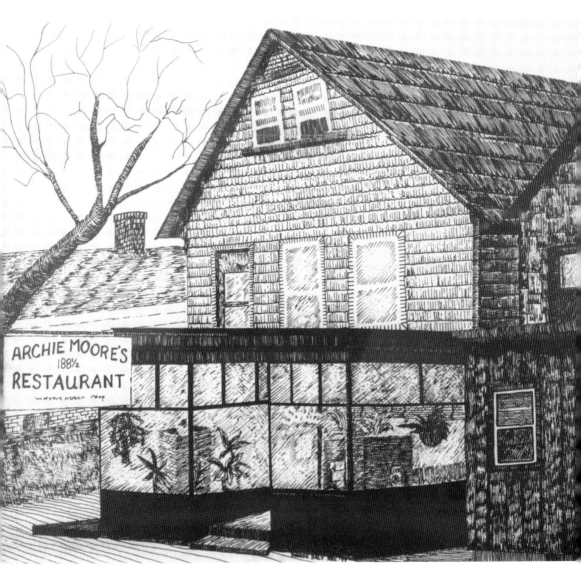

Archie Moore (ABOVE AND OPPOSITE PAGE)

Irishman Archie Moore opened his bar in 1898 on the corner of Willow and Anderson Streets, beginning a neighborhood institution that has continuously thrived and grown. But Moore died suddenly in 1914, leaving his bar to his wife, Jane. In 1916, Jane Moore moved the old bar across the street, living upstairs with her sons Archie Jr. and Eddie. During Prohibition, she renamed the joint Moore's Café and created a narrow secret stairway to the second-floor speakeasy. The sons took over the bar until Archie Jr. passed away on November 9, 1959, when it was sold. Archie Moore's is still going strong on Willow Street, now with four others located around the state. These bars have held onto their rich history and added the now-famous buffalo barbecue wings to the layers of beer and varnish. (Above, drawing by Denise Daly, courtesy of Archie Moore's; opposite top, courtesy of US Department of State.)

107

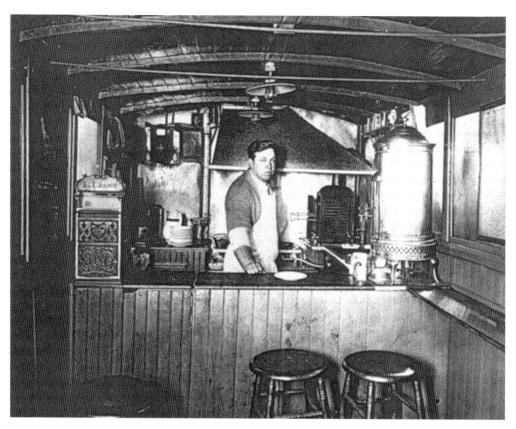

Louis Lassen

In 1886, German immigrant Louis Lassen came to the United States to try out a new life. He made his way to New Haven arriving in the Oak Street neighborhood, a thriving melting pot near the train station. Lassen began, as many newcomers to this city do, as a food peddler. He pushed around a wooden cart selling butter and eggs. He had purchased his home at 45 Elliot Street and housed his cart in a shed in the backyard. In 1895, he began adding lunch items to his cart. The most important dish Lassen served, beginning in 1900, was the hamburger, made from steak sandwich leftovers, ground into paddies. This is considered the first time that a hamburger sandwich was made in the United States. Along with this new dish, Lassen's business was expanding, so new quarters were needed for his inventory. In 1912, Lassen found a new place to serve his lunches, a little one-room office wing attached to an old harness shop on George Street. This was smack-dab in the middle of the business district, and business thrived. Over the years, he served tens of thousands of burgers, passing the family business down to his sons and grandsons. In 1966, Louis' Lunch was first threatened with destruction by the hands of redevelopment. Lassen's grandson Ken Lassen asked people to help prepare for their move by collecting bricks and stones from around the world, including from the Taj Mahal, the Pantheon, Fort Sumter, and Machu Pichu. Lassen also collected bricks from buildings that were being demolished around his restaurant. In that way, when they were forced to move to a new location, there would be a connection from every corner of the earth. In 1974, the city finally planned a new medical tower development on the site of Louis' Lunch. Only after Lassen's pleas and outrage from loyal patrons did the city leave an option to have the little restaurant building moved. Finally, after months of tension, a suitable site was found a couple blocks away at 263 Crown Street, and the Redevelopment Agency paid $8,000 to move the old landmark in June 1975. Louis' reopened in February 1976 to happy crowds of Yalies and townies. In 1990, Congresswoman Rosa DeLauro (see page 32) filed paperwork with the Library of Congress stating that Louis' Lunch made the first hamburger sandwich in America. (Courtesy of LOC.)

Louis' Lunch

Louis' Lunch, pictured in 2013, has a storied past and continues to be a destination for locals and tourists. The restaurant has been greatly featured in the media for its history as well as its food. It is now run by the fourth generation of the Lassen family. Louis' does not serve ketchup, or any other condiment; the owners want to keep the menu just as traditional as it was years ago.

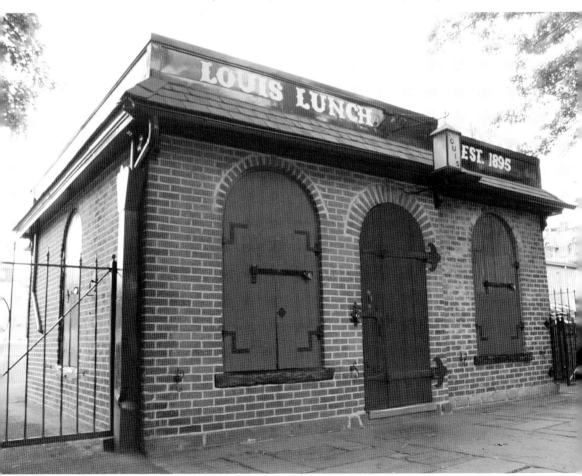

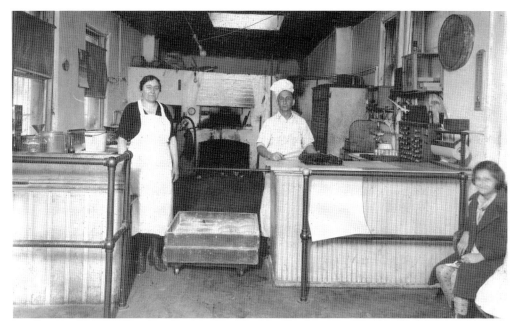

Frank Pepe

At 16 years old, Frank Pepe came to the United States from Naples, Italy, to find employment. He worked briefly at Sargent Manufacturing Company, the largest employer of Italian immigrants and maker of door locks and accessories. Pepe returned to Italy to fight during World War I, married, and came back here in 1920. He baked for others until an opportunity to begin his own bakery appeared, and he rented a back building from the Boccamiello family. Pepe began by delivering bread and pizza to local factories and the food terminal. He operated out of a cart and carried the pizzas in a tin pan on top of his head. With the help of his wife, Filomena, who, unlike Pepe, was literate and could speak and write in English, they established their bakery as a restaurant in 1925. The c. 1925 photograph above is of Frank and Filomena Pepe. Below, the restaurant is pictured around 1961. (Above, courtesy of Frank Pepe Pizzeria Napoletana; below, courtesy of NHM.)

For Those Who Know and Want the Very Best

FRANK PEPE

PIZZERIA
SINCE 1925

HIGHEST QUALITY INGREDIENTS

Imported Italian Plum Tomatoes

100% Pure Italian Olive Oil

Imported Italian Cheese

Bacon from Sperry and Barnes

Big Sweet Spanish Onions

Homemade Italian Pure Pork Sausage

Full Cream Muzzarella

Anchovies Imported from Portugal

Mushrooms Imported from France

Pepe's Own Perfect Pie Dough

ALL PIZZA MADE TO YOUR SPECIAL ORDER ● A FIVE MINUTE WALK FROM THE GREEN ● CONVENIENT PARKING FACILITIES ● TWO LARGE DINING ROOMS — 25 BOOTHS ● RHEINGOLD BEER ON TAP AND IN BOTTLES ● RHODE ISLAND CLAMS ON THE HALF SHELL FRESH DAILY — WILL DELIVER LARGE ORDERS ● OPEN DAILY EXCEPT ⌐ ⌐ 11:30–1:00, SATURDAY 11:30–2:00, SUNDAY 2:30–12:00.

See It Made in the World's Largest
Open Hearth Apizza Oven!
The One and Only Frank Pepe's

157 Wooster Only Location UN 5-9906 — UN 5-5762

Frank Pepe Pizzeria Napoletana

The first pizzas were called Neapolitan Tomato Pies, or Apizza, pronounced in their dialect as "abeetz." They were thin-crust pies with tomato sauce and grated cheese with the option of anchovies as a topping. Business was booming, and in 1937, Pepe purchased the building next door and moved his pizzeria to larger quarters. His old place was taken over by a Mr. Boccamiello and called The Spot. In 1938, Pepe's nephew Salvatore Consiglio (see page 113), who had been working under Pepe, opened his own pizzeria down the block, called Sally's Apizza. The pizza craze in New Haven was in full swing thanks to Frank Pepe. Over the years, Pepe's has become a phenomenon, even having hosted Presidents Reagan and Clinton. Visitors from around the world wait in lines 50-people long just to try this legendary pizza. Now, Pepe's has numerous locations throughout Connecticut and in New York. But the original Frank Pepe's is the "Old Reliable." This advertisement is from 1959. (Courtesy of *Yale Daily News*.)

Harry Lender

In 1927, Harry and Rose Lender came from Lublin, Poland, to New Haven to start a new life. Harry Lender was a baker and brought the recipe for the traditional Jewish baked good called the bagel. He set up his first bakery on Oak Street in the thick of the Jewish immigrant neighborhood. Harry Lender sold bagels from his cart, like many smaller businesses operated. Eventually, he moved nearby to the Hill neighborhood to a house at 20 Baldwin Street. In a garage in the rear, bagels were being hand rolled and baked, dozens per day. He named his business the New York Bagel Bakery. His sons Murray, Marvin, and Sam also joined in from an early age to help make more bagels. In the 1950s, Harry purchased a freezer to better preserve bagels that were being shipped around the state. After he passed away in 1960, his sons took over the business, and in 1964, they built a large bakery in West Haven, employing 100 hands and popping out 120,000 bagels a week. This began the widespread sale of frozen bagels to 30 states around the country. Another plant was added in New Haven and then two more plants were built in the Midwest during the 1980s. In 1984, H. Lender & Sons Bakery was sold to Kraft Foods, and Murray Lender stayed on as company spokesman. He opened local restaurants featuring bagel chips and popular Jewish foods. Always humorous, Murray was quoted as saying, "I never walked into anybody's office without a toaster under one arm and a package of bagels under the other." Pictured around 1950 are (from left to right) Harry, Murray, Marvin, Sam, and Michael Lender. (Courtesy of Carl Lender.)

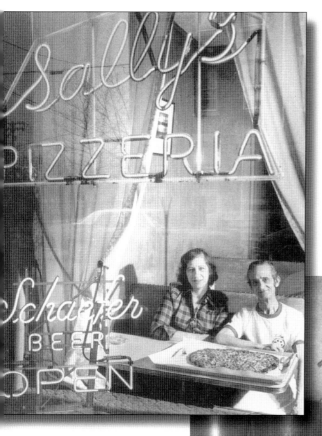

Sally and Flo Consiglio

In 1938, Salvatore "Sally" Consiglio, who was working with his uncle Frank Pepe (see page 111) making pizza, wanted to make his own pies. So Consiglio and his wife, Flo, opened Sally's Apizza just down the block on Wooster Street. They began to develop quite a following, especially from Yale. Consiglio's brother Tony was also best friends and personal valet to Frank Sinatra and would bring the famed singer to the family spot. It was Sinatra's favorite, and he became intimate with the family. The Consiglios helped raise lots of city kids over the years, and Sally's is still run by the family. (Both courtesy of Sally's Apizza.)

Vinnie and Mary Gagliardi
Starting in 1975, Gag Jr.'s graced the corner of Chapel and Park Streets, serving breakfast and lunch. Gagliardi's father, Antonio, began a café in 1920 at 74 Greene Street, and it was known for serving hot sub sandwiches. Antonio began working with his father and, eventually, opened his own place on Broadway, called Gag Jr.'s. After its move to Chapel Street, nearby the Yale Repertory Theater, Gag Jr.'s began to have its own rep for being the place to hang out. Over the years, up-and-coming actors

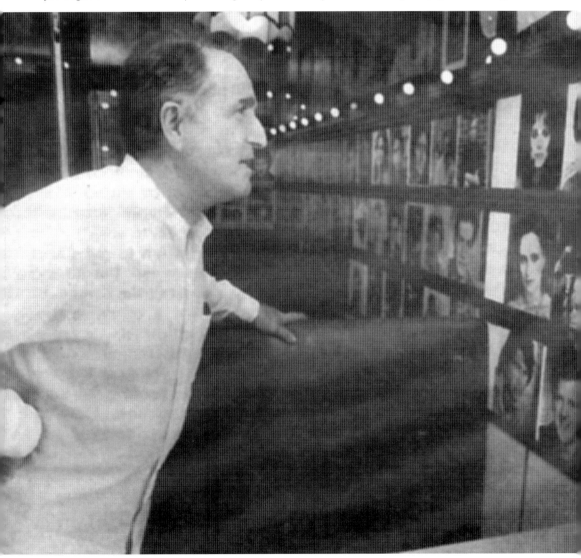

like Meryl Streep, James Earl Jones, and Christopher Walken, have signed their photographs, which eventually lined every corner of the little diner. In 1989, the family consolidated their energy into Gag's Liquor Store next door, and the old luncheonette closed for good. Today, the corner signs that honor the tradition were set up by Vinnie and Mary. (Opposite, photograph by Virginia Blaisdell, courtesy of Nick Boldano; below, photograph by Cesar Tores, courtesy of Nick Boldano.)

Yoshi and Bun Lai

Miya's sushi opened its doors in 1983, welcoming New Haven and Yale to their first taste of sushi. Owner Yoshi Lai, a native of Japan, believed that there would be a market for this traditional Japanese concept. Named for her daughter Mie, the family restaurant gained the help of Mie's older brother Bun. The mother-and-son team has completely changed the rules of sushi in recent years. Bun Lai has focused his attention on serving sustainable seafood to help combat over-fished species that are commonly served as sushi. He has also introduced the idea of eating invasive species, critters, and plants that tend to overwhelm the environment. Lai has been featured on television shows, magazine, newspapers, and lectures around the country. Admittedly, the author has a soft spot for Miya's and its home-away-from-home experience. (Courtesy of Bun Lai.)

CHAPTER SEVEN

Lagniappe

The word "lagniappe" comes to the United States by way of New Orleans, and from there, it was carried on after traveling from the South. It means a little something extra, like a gift. This chapter acts like a gift to the reader and showcases people who often get left out of traditional history textbooks.

These people and their stories are the true legends that usually live on longer than the stories of philanthropists or industrialists might. It must be one's human nature to try to take interest and understanding in society's oddities and outcasts. Captain Thunderbolt was more of a myth than a reality, but his story was of a fugitive bandit who changed his profession and moved across the ocean. He did some secretive business here but caused quite a ruckus during his brief stay. Milton J. Stewart was an eccentric hermit who lived on top of a cliff, and one day he built a steamboat up there. He was eventually booted off the rock when it was turned into a park. Another hermit, William Baldwin Beamish dressed as a man but was found out to be woman, only a month before she died.

Like any good book, the reader is left with a healthy dose of death and destruction. Jennie Cramer was found dead in the water. The suspects were a prostitute and the son and nephew of the city's wealthiest man. The case went unsolved, and the poor girl's family went down for the count, too. The next character would not stay down, in or out of the ring. Salvatore "Midge Renault" Annunziato, a boxer, was considered New Haven's most notorious mobster. He was violent, unpredictable, gruesome, and yet charming and generous. He was arrested and jailed almost every year, but his final disappearing act is the ultimate cliffhanger of this book.

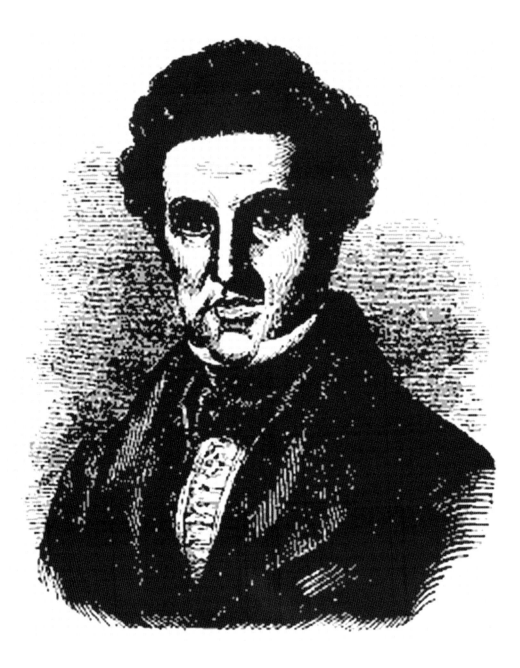

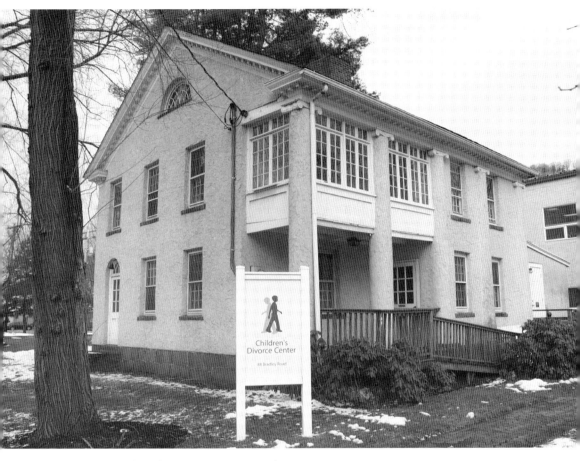

Captain Thunderbolt (ABOVE AND OPPOSITE PAGE)
This rouge character showed up in New Haven lore with tales of an angry pirate with a bounty on his head. The real story about Captain Thunderbolt appears to refer to John Wilson, a Scottish highway robber who fled to Vermont with the help of his brother, Woodbridge resident Robert Wilson, who lived at 88 Bradley Road. While in Vermont, Captain Thunderbolt became a school teacher, building a round schoolhouse, now exhibited as a museum. Then he became one of the more respected doctors in that state, only showing his peculiarities once in a while. Captain Thunderbolt's visits to his brother must have made an impression on locals here since a number of stories relate this character making face at Pendleton's Tavern on Whalley Avenue in Westville. His brother's old house is still extant, an unusual stuccoed, architectural gem at the base of West Rock. The drawing on the opposite page is from 1847. The 2010 photograph above, taken by the author, is of 88 Bradley Road.

William Baldwin Beamish

"I am 68 years old and was born in Cork, Ireland, and that's all I'll tell you." On December 22, 1932, when a visiting nurse found old William Baldwin Beamish in his small shack, he had nearly died from malnutrition and kerosene fumes. At the hospital, he was placed in the men's ward, but Beamish was discovered to be a woman. News reports ran this story from Baltimore to Ireland. Beamish had androgynous features, smoked a pipe, and carried herself like men of her era. Her home, a small millhouse, was also her print shop. Beamish would tell visitors that Sophie M. Beamish, her supposed wife, died on April 7, 1900, but her identity is a mystery. Beamish was first listed as living here in 1892. Nobody could find out her real name or any other details of her life. This article is from 1925.

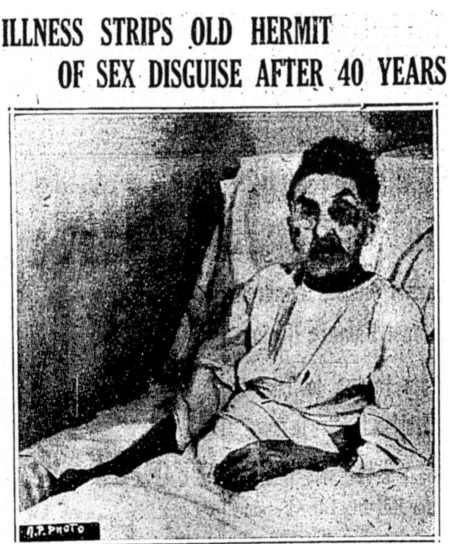

ILLNESS STRIPS OLD HERMIT
OF SEX DISGUISE AFTER 40 YEARS

Illness and the infirmities of old age have disclosed the masculine disguise a 68-year-old Hamden, Conn. woman used successfully for the past 40 years or more to mask her sex and identity. The woman has lived the life of a hermit for the past score of years and was known to her neighbors as "William Baldwin Beamish." Authorities who sought to question her at the Grace Hospital in New Haven were told: "I am 68 years old and was born in Cork, Ireland, and that's all I'll tell you."

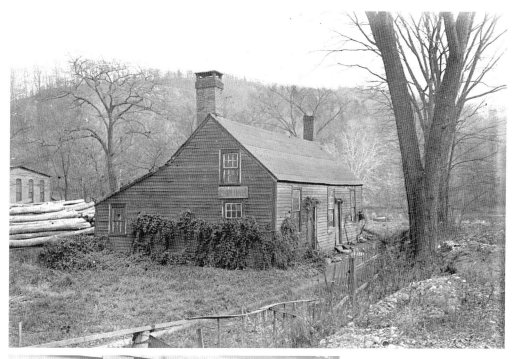

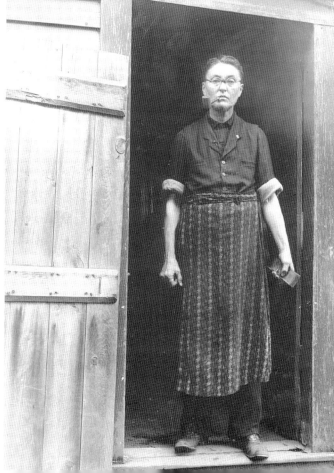

Beamish Home

Beamish smoked a tobacco pipe, wore men's clothing, and had facial hair around her chin and very muscular arms and hands. The old house where Beamish lived was likely the old millhouse for Christopher Todd, who established New Haven's first gristmill nearby. In 1798, Eli Whitney (see page 50) purchased this site to fulfill his US government contract to make muskets. Over the years, mill operators have successively raised the level of the nearby dam to allow more water to be held and guarantee a consistent outflow.

DEDICATED TO THE MEMORY OF
JENNIE E. CRAMER,
FOUND DEAD,
UPON WEST HAVEN BEACH, AUGUST 6TH 1881

FOUND DRIFTING WITH THE TIDE

WORDS & MUSIC
BY A.G. WILLIS.

④

NEW HAVEN CONN.
C.M. LOOMIS

NEW YORK
SPEAR & DEHNHOFF.

BOSTON
WHITE, SMITH & CO.

NEW YORK
W.A. POND & CO.

Jennie Cramer (BELOW AND OPPOSITE PAGE)

The body of a Jennie Cramer, 20 years of age, lay lifeless and face down at the West Haven Beach on a muggy Saturday morning in 1881. The key suspects were James Malley, who had a love interest with Cramer and was son of Edward Malley, a wealthy man who ran the largest department store in the city; James's cousin Walter; and Blanche Douglass, a prostitute from New York. Evidence pointed to Cramer's death as arsenic poisoning, and she was violently raped the day before she died. All three were arrested for murder on August 15. The jury could not convict the trio based on the circumstantial evidence given. Soon after the trial started, Cramer's father died, her mother hanged herself, and the Malley's department store was burned through arson. The case has never been fully solved. (Opposite, courtesy of NHM.)

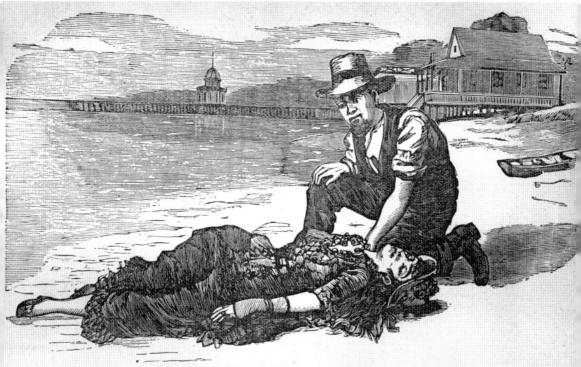

ASA CURTISS, THE FISHERMAN, FINDING THE BODY OF JENNIE E. CRAMER ON THE BEACH, AT WEST HAVEN, AUGUST 6TH, 1881.

Milton J. Stewart

Milton J. Stewart was one of New Haven's most eccentric characters. Stewart began squatting in 1853 on the towering cliffs of East Rock. He built a stone house on the summit of the rock with views in every direction, the view south toward New Haven is pictured above. When the city began planning to make East Rock one of its new public parks in 1880, Stewart protested. He closed all access roads and shunned visitors from attempting to step foot on his land. But on May 15, 1882, Stewart chased two amblers, and one man claimed Stewart struck him, which landed Stewart in jail. On June 26, 1882, Mrs. Stewart went to fetch water from a spring when two young villains from Fair Haven attacked and raped her. She escaped and ran for help, leading to the culprits' arrest; they were sentenced to one year in jail. Once released from jail, Stewart began building a 100-passenger, 50-foot steamboat on top of East Rock. He said, "I could go to Europe in it," but people suspected that he was building an ark in preparation for a big flood. His boat, an oversized sharpie for oystering, was later used as

a model for all future sharpies. Stewart began moving the boat down the rock in July. Townspeople recalled that this was one of the biggest spoofs of the time, and Stewart accepted that he would build a boat by the water next time. In 1884, the city condemned his property and took his land through eminent domain, paying him a meager $13,000 for the entire rock. Stewart built a house at the base of the rock and decided to live in its cellar. He used that money to build 12 houses on swampy land along State Street not far from the base of East Rock, seen near the bridge in the center of the image above. Stewart, being the eccentric person who he was, had trouble collecting rent from his tenants, and the houses began enter states of disrepair. They were dubbed "Stewart's Dirty Dozen" because of their increasingly unsavory condition. His reaction to his decaying houses was to claim $10,000 from the city for damages caused by the regrading of the street. A number of respected citizens defended his claim, but the city ended up only delivering less than $2,000 to Stewart. In the 1890s, after some years of poor health, he died leaving his wife and son on July 27, 1897, at age 74. This photograph is from 1895.

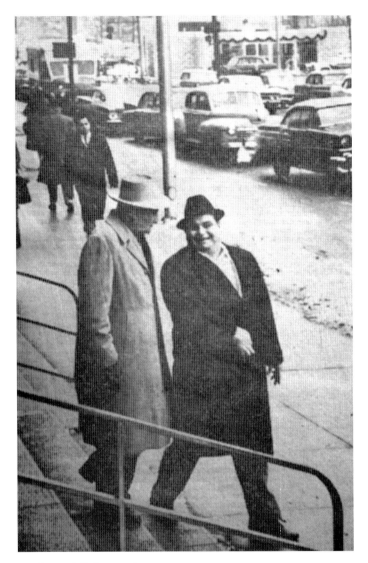

Salvatore "Midge Renault" Annunziato

Brought up poor in a family of 10 kids and an alcoholic father in Fair Haven, Salvatore "Midge Renault" Annunziato, pictured in 1962, was surrounded by angst and anger in his own house. Although he was one of the least problematic of his male siblings, the short and stocky Midge began to steal, hit, and lie at an early age. He was sent to reform school where he began to box. After school, in 1936, he began boxing competitively earning the name "Midge Renault," but his angry style was usually turned against him. Starting with holdups and beat downs in 1938, Midge became connected with the Genovese crime family and became a "made man." He was also connected to local politicians, including Mayor Richard C. Lee (see page 30). He was a notoriously bad driver and a drunk who loved violence, but he was also a gregarious and generous party animal who would share his wallet and his car. He was constantly in and out of jail for mostly violent crimes and was even convicted along with his son for attempted murder in 1971. On the evening of June 19, 1979, after years of destructive and elusive behavior, at home in East Haven, Midge said goodbye to his wife, entered a waiting car, and was last seen at the Branford Motor Inn, with a wad of cash. He was under a federal indictment at the time, and federal agents warned him that there was a mob hit out for him. His disappearance is still a mystery. (Courtesy of NHFPL.)

INDEX

Find more books like this at
www.legendarylocals.com

Discover more local and regional history books at
www.arcadiapublishing.com